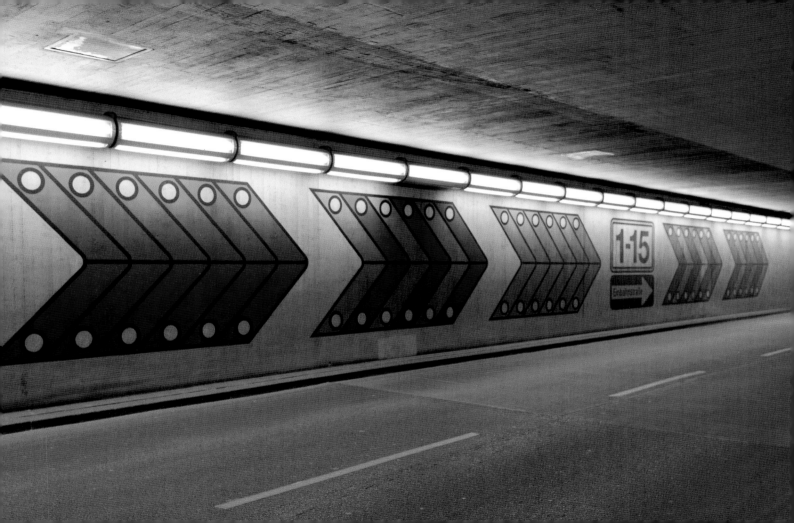

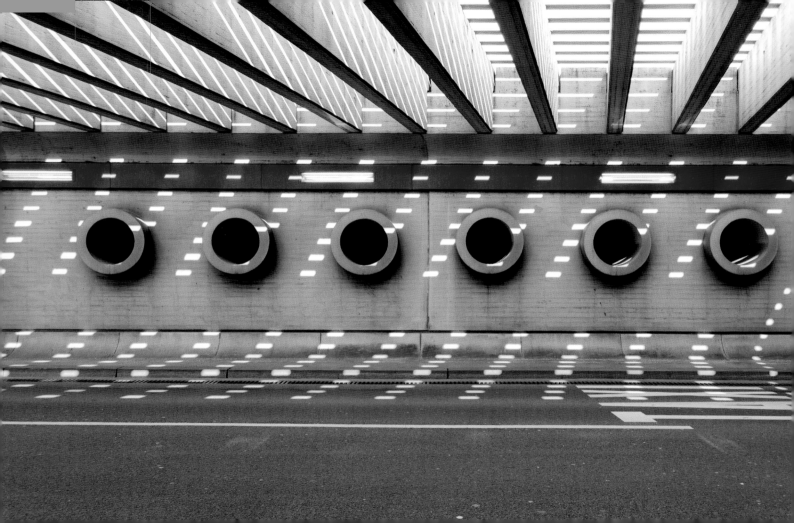

The Essence of Berlin-Tegel

Taking Stock of an Airport's Architecture

Peter Ortner

Der menschlichste aller Flughäfen

Florian Heilmeyer

Ein Besuch des Flughafens Tegel im Winter 2019 zeigt ein ziemlich verschlissenes Gebäude, das tapfer gegen den Kollaps kämpft. Die sogenannten „Schnellvorfahrten", die es Reisenden ermöglicht, mit ihren Autos direkt bis vor die Check-In-Schalter zu fahren, sind vollständig überfüllt. Die Blechlawine vor dem „Drive-In-Flughafen" steht, hupt und stolpert schrittweise vorwärts. In den Schiebetüren drängen sich Hinaus- und Hineineilende gegenseitig aus dem Weg, die Gänge sind voller Passagiere, die langen Warteschlangen vor den Schaltern versperren Vorübereilenden den Weg. Vom genialen Raumkonzept der „kurzen Wege", das Tegel vor anderen Flughäfen auszeichnet, bleibt wenig übrig, wenn die Wege zwar kurz, aber verstopft sind.

Die deutlichen Gebrauchsspuren des einst so hochgelobten Gebäudes sind in Tegel allerdings Absicht. „Wir fahren Tegel bewusst weiter auf Verschleiß", ließ sich der Chef der Berlin-Brandenburger Flughafengesellschaft Engelbert Lütke-Daldrup 2017 erstaunlich unverblümt zitieren.[1] Bis zur Eröffnung des neuen Flughafens BER in Schönefeld soll kein Cent überflüssig in TXL investiert werden. Da die einst für Oktober 2011 geplante BER-Eröffnung nun bereits siebenmal verschoben wurde, muss der Tegeler Flughafen seit 9 Jahren improvisieren. Die Dramatik drückt sich in Zahlen aus: Einst für 2,5 Millionen Passagiere im Jahr ausgelegt, wurden 2019 über 22 Millionen Passagiere abgefertigt. Statt des geplanten zweiten großen Terminal B, mit dem die Kapazitäten verdoppelt worden wären, entstanden immer nur provisorische Terminals. Die Fluggäste der Billigfluglinien werden von Terminal C aus zu Fuß über das Rollfeld zu ihren Flugzeugen gebracht. Der Blick von der Besucherterrasse auf dem alten Terminal A zeigt ein schönes Gewimmel. Im Rhythmus der Gezeiten füllt und leert sich das Flugfeld. Sonst lässt sich diesem Betrieb jedoch wenig Positives abgewinnen.

Sechseckiges Gesamtkunstwerk

Gedacht war das alles ganz anders, als 1965 drei junge und völlig unbekannte Architekten den internationalen Wettbewerb für den neuen West-Berliner Flughafen gewinnen konnten. In der gesamten Geschichte der Architekturwettbewerbe in Deutschland gab es selten einen so großen Auftrag für ein Büro, das zum Zeitpunkt des Gewinns schlicht noch nicht existierte. Meinhard von Gerkan, Volkwin Marg und Klaus Nickels hatten gerade erst ihr Diplom an der TU Braunschweig erworben und zuvor, so von Gerkan, „nicht mal ein Gartenhaus" gebaut.[2] Und dennoch bekräftigte der damalige Direktor der Flughafengesellschaft Robert Grosch: „Wir waren beeindruckt von der analytischen Kraft" und: „Es ist das optimale Ergebnis."[3] Profitieren konnte die junge Arbeitsgemeinschaft dabei vom Diplomentwurf von Gerkans, der die Vision eines „Drive-In-Flughafens" bereits für Hannover-Langenhagen ausgearbeitet hatte. Umso wichtiger ist es aus heutiger Sicht, auf den wundervollen Mut der Flughafengesellschaft und der Berliner Politik hinzuweisen, nicht nur das Konzept im Wettbewerb auszuzeichnen, sondern den jungen Architekten auch alle Folgeaufträge zu geben – und somit die Gesamtgestaltung von der Verkehrs-, der Landschafts- und der

The Most Human of All Airports

Florian Heilmeyer

A visit to Tegel Airport in the winter of 2019 reveals a rather worn out building bravely fighting against collapse. The drive-up lanes that allow passengers to go directly from their car to the check-in counter are completely overcrowded. And the avalanche of vehicles arriving here is hardly moving—honking and inching its way forward stop-and-go. People rushing in and out of the sliding doors push each other out of the way, and the long lines in front of the check-in counters block the path for others who are trying to hurry past. Not much remains of the brilliant spatial concept of "short distances"—which sets Tegel apart from other airports—if the distances are short but congested.

At Tegel, however, the clear signs of use that mark this once highly praised building are intentional. "We are deliberately continuing to operate Tegel as it wears out," admitted Engelbert Lütke-Daldrup, the head of the airport company, in 2017 with astonishing bluntness.[1] The intention is to avoid investing even a single cent in TXL before the new airport BER opens in Schönefeld. This date, first scheduled for October 2011, has now been postponed seven times, meaning Tegel Airport has had to improvise for nine years. The gravity of the situation is captured in figures: once designed to handle 2.5 million passengers a year, in 2019 the airport handled over 22 million. Instead of the planned second large Terminal B, which would have doubled capacity, only temporary terminals were built. Passengers on low-cost airlines board their planes from Terminal C after crossing the tarmac on foot. The view from the visitors' terrace in the old Terminal A reveals a beautiful, teeming crowd, the airfield filling and emptying like the tides. Otherwise, however, there's not much good to be said about the operations.

A Hexagonal Gesamtkunstwerk

The future looked quite different when three young and completely unknown architects won the international competition for the new West Berlin airport in 1965. In the entire history of architectural competitions in Germany, there has hardly been any such large commission awarded to an office that simply did not exist when the competition was won. Meinhard von Gerkan, Volkwin Marg, and Klaus Nickels had just graduated from the Technical University of Braunschweig, and according to von Gerkan they hadn't even built "so much as a garden house."[2] Yet as the director of the airport company at the time, Robert Grosch, explained: "We were impressed with the analytical power," and "It's the optimal result."[3] The young team was able to benefit from the designs that Gerkan had created for his thesis, where he had already worked out the vision of a "drive-in-airport" for Hannover-Langenhagen. From today's perspective, it's thus all the more important to point out the amazing courage of the airport company and of Berlin's politicians to not only choose the concept in the competition but also award all of the follow-up contracts for the project to the young architects—entrusting them with the overall design (traffic, landscape, and interior planning, including the furniture) as well as the planning of all outbuildings from the hangars, air

Innenraumplanung inklusive der Möblierung sowie die Planung aller Nebengebäude von Hangars, Luftfracht- und Betriebsgebäuden bis zu Energiezentrale, Streugutlager, Bushaltestellen und einer öffentlichen Tankstelle. Dies war nebenbei bemerkt auch eine Entscheidung, aus der eines der erfolgreichsten deutschen Architekturbüros entstanden ist, das bis heute gewaltige Gebäude auf der ganzen Welt errichtet und derzeit über 500 Mitarbeiter in 14 Niederlassungen beschäftigt. Und die Entscheidung bewährte sich: Im November 1974 wurde TXL pünktlich eröffnet und blieb – entgegen allen verfrühten Medien-Verspottungen als „Teglitzer Kreisel"[4] und „Luftschloß"[5] – knapp 5 Prozent unter den kalkulierten Kosten von 450 Millionen D-Mark.

Er war aber nicht nur günstig und pünktlich fertig. Der Flughafen Tegel ist vor allem ein heute noch beeindruckendes Gesamtkunstwerk, in dem sich das Größte im Kleinsten wiederfindet. Für den Entwurf des Terminals wählten die Architekten die Figur eines großen Sechsecks mit 120 Metern Kantenlänge. An seinen Außenseiten bot das Hexagon viel Platz für den großräumigen Luftverkehr, während im Innern ein gut proportionierter offener Hof blieb, der auf das menschliche Maß und den individuellen Pkw-Verkehr abgestimmt werden konnte. Zwischen diesen extrem unterschiedlichen Maßstäben des Luft- und des Straßenverkehrs vermittelt in Tegel ein elegantes Gebäude, dem man zunächst kaum ansieht, wie schmal es eigentlich ist. Erst in der Luftsicht – also beim Starten oder Landen etwa – wird es ganz offensichtlich: Von der Auto- bis zur Flugzeugtür sind es im besten Fall nur 28 Meter. Das war der Kern der Idee, einen „Flughafen der kurzen Wege" zu bauen, wo all die Lästig-keiten des modernen Reisens, Check-In, Sicherheitskontrollen, Gepäckabgaben, Toiletten- und Warteräume, architektonisch aufs kompakteste zusammengeschnürt wurden. „Zwar funktionieren alle Flughäfen der Welt irgendwie", urteilte Architekturkritiker Manfred Sack bei der Eröffnung 1974, „doch mir scheint, daß die Tegeler Konzeption die einleuchtendste ist."[6] Allerdings bedeutete das eine grundlegend dezentrale Organisation. An jedem Gate musste alles vorhanden sein. Das ist radikal passagier- und menschenfreundlich, dafür unwirtschaftlicher im Vergleich mit anderen Flughäfen, an denen alle Passagiere mit ihrem Gepäck durch eine zentrale Kontrolle geschleust werden. Davon später mehr.

Gestaltung ohne Dogma

Aus dem Hexagon entwickelten die Architekten einen geometrischen Handwerkskasten gefüllt mit gleichschenkligen Dreiecken und Sechzig-Grad-Winkeln, die überall auf dem Flughafen zu entdecken sind: im Winkel der Automatiktüren, im Grundriss der Treppen- und Aufzugstürme, im Muster der Deckenplatten, im Glasdach der Eingangshalle und natürlich auf dem Dach des Terminals, das als Besucherterrasse das Sechseck begehbar und damit den Gesamtentwurf lesbar macht. Gleichzeitig widerstanden die Architekten dem Reiz, das Sechseck zum Dogma zu machen. So führten sie ein zweites omnipräsentes Element ein: die schwungvoll gerundete Ecke. Sie ist das Verbindungsglied zwischen den unbeweglichen Gebäuden und der aerodynamischen Flugzeuggestaltung. Die runde Ecke ist mindestens so allgegenwärtig wie das Sechseck und begegnet uns unter anderem in den Fußgängertunneln unter

freight, and operations buildings to the powerhouse, storage for grit, bus stops, and a public gas station. This was coincidentally also a decision that led to the founding of one of the most successful architectural firms in Germany, which to this day constructs enormous buildings all over the world and currently employs over 500 people in 14 offices. The decision paid off: in November 1974, TXL opened on time and—contrary to the early derision in the media of the building as the "Teglitzer Kreisel" [4] or a "Luftschloß" [5] (castle in the sky)—at a budget that was 5 percent below the planned cost of 450 million deutschmarks. But the airport was not only on time and under budget. Above all, today Tegel Airport remains an impressive Gesamtkunstwerk in which the overall conception is reflected in the smallest detail. For their design of the terminal, the architects chose the figure of a large hexagon with edges of 120 meters. On its outer sides, the hexagon offered plenty of space for the larger-scale aircraft, while the inner sides enclosed a well-proportioned, open courtyard that could be adapted to a human scale and to individual automobile traffic. At Tegel, an elegant building mediates between these extremely different dimensions—so elegant, in fact, that one hardly notices just how narrow it is. Only when viewed from the air—for example, during take-off or landing—does this become completely obvious: there are as little as 28 meters between the doors of the cars and the aircraft. This is the nucleus of the idea to build an "airport of short distances" in which all the annoyances of modern travel—check-in, security checks, baggage claim, toilets, and waiting rooms—would be architecturally bundled together as compactly as possible. "All the airports in the world do manage to function somehow,"

was the verdict of architecture critic Manfred Sack at the opening in 1974, "but it seems to me that Tegel's concept is the most convincing." [6] However, this meant a fundamentally decentralized form of organization: everything had to be available at every gate. This is radically convenient for passengers and people but less economic compared to other airports, where all passengers are channeled, with their luggage, through a central management point. More on that below.

Design without Dogma

Out of this hexagon, the architects developed a geometric toolbox filled with isosceles triangles and sixty-degree angles that can be found everywhere at the airport: in the angle of the automatic doors, in the floor plan of the towers holding the stairs and elevators, in the glass roof of the entrance hall and, of course, on the roof of the terminal, which functions as a visitor terrace that allows the hexagon as such to be experienced on foot and thus renders the overall design legible. At the same time, the architects resisted the temptation to turn the hexagon into a dogma. For instance, they introduced a second omnipresent element: swinging, rounded corners. These corners form the connecting link between the immobile buildings and the aerodynamic design of the aircraft. Rounded corners are at least as ubiquitous as hexagons. They greet visitors in the pedestrian tunnels under the taxiway bridge, in the windows, in the once bright-red plastic panels on the facade, in the curved railings, in the tables in the restrooms, and—everywhere!—in the beautiful graphic guidance system created by the Hamburg painter Werner Nöfer. This system directs visitors along every

der Rollfeldbrücke, den Fensterscheiben, den einst knallroten Kunststoffpaneelen an der Fassade, in den geschwungenen Geländern, Waschtischen und – im Überfluss! – in dem wunderschönen grafischen Leitsystem des Hamburger Malers Werner Nöfer. Mit kräftigen Farben, Zahlen und Piktogrammen begleitet es alle Wege: Gelb für das, was primär mit dem Fliegen zu tun hat; Grün für Sekundärfunktionen wie Taxi, Bus, Restaurant, Friseur oder Post; Rot als Warn- und Schmuckfarbe.

Diese alles durchdringende Gesamtgestaltung war nicht nur 1974 eine Sensation. Sie ist es noch heute. Vielleicht sogar noch mehr, betrachtet man die anderen Riesenflughäfen dieser Welt, die kaum mehr als Shopping Malls mit schlecht ausgeschildertem Fluganschluss sind; Tempel des Wartens, in denen die Passagiere durch die Flaschenhälse der Sicherheitskontrollen geschleust werden, um sich dann in perfekt glitzernden, absurd teuren Konsumwelten des Spätkapitalismus wiederzufinden. Rein ökonomisch gesehen kann das Warten dort nicht lange genug dauern, denn umso mehr wird konsumiert. Da wirkt die damalige Aussage der TXL-Architekten, man wolle die „notwendige Abfertigungsmaschine durch Gestaltung humanisieren",[7] umso überzeugender. Ein menschlicherer Flughafen als TXL ist noch nicht gebaut worden.

Denkmal der Unschuld

Ein Flughafen, dem die Überwältigungseffekte heutiger Spektakel-Architekturen vollkommen fremd sind und der auch 2020, im verschlissenen Zustand, mit Freude zu durchlaufen ist. Sicher, hier und dort fehlen Elemente. So wurde das sechseckige rotbraune Klinkerpflaster von den Böden entfernt – seine tiefen Rillen waren schwer zu reinigen und bildeten für die aufkommenden Rollkoffer heftige Stolperfallen. Und die stille Klarheit des vollständig erhaltenen Leitsystems leidet unter der mittlerweile allzu schrillen und allgegenwärtigen Werbung. Dennoch: Das Gebäude spricht. Heute sogar mehr als damals, lassen sich doch in Tegel zusätzlich auch die Veränderungen der zivilen Luftfahrt in den letzten 40 Jahren ablesen, allein die ständig verschärften Sicherheitsbedingungen, denen TXL nicht gewachsen ist. „Damals hat ja kein Mensch daran gedacht, dass es eines Tages zu Flugzeugentführungen kommen würde!", sagte Meinhard von Gerkan in einem Interview 2012.[8] Landshut, Lockerbie und Nine-Eleven – das war 1974 schwer vorstellbar. Ebenso wenig wie die immer größeren Wünsche einer konsumistischen Flächenverwertung, die mit den Sicherheitsbestimmungen Hand in Hand gingen. Diesen Kräften, die auf allen Flughäfen der Welt heute für riesige zentrale Abfertigungen sorgen, war das entschlossen dezentrale Konzept Tegels nicht gewachsen. Selbiges gilt für die Anforderungen an einen Umsteigebahnhof für Anschlussflüge. Tegel ist eher das, was für die Eisenbahnen früher der Kopfbahnhof war: eine Endhaltestelle. Das lässt sich auch kaum umbauen. Diesen globalen, terroristischen und kapitalistischen Entwicklungen steht TXL als Denkmal einer so viel unschuldigeren Zeit entgegen. Umso intensiver beeindruckt das Erleben des alten Flughafens. Was aber wird davon bleiben, wenn TXL nach 2020 zur Urban Tech Republic der Beuth-Hochschule umgebaut wird? Wenn hier keine Flugzeuge mehr halten, wenn aus dem Tower wie geplant ein Kletterturm wird und die kurzen Wege durch das so grandios funktionale Gebäude endgültig Geschichte sind?

path with its strong colors, numbers, and pictograms: yellow is for everything primarily related to flying; green is for secondary functions such as taxis, buses, restaurants, a hairdresser, or the post office; and red is used as a warning and decorative color. This all-pervading overall design was a sensation—and not only in 1974. It remains a sensation today, and perhaps even more so if one looks at the world's other gigantic airports, which are little more than shopping malls with poorly signposted flight connections—temples for waiting in which passengers are channeled through the bottlenecks of security checks, only to find themselves in perfectly glittering, absurdly expensive, late capitalist worlds of consumption. From a commercial perspective, there is no such thing as waiting here too long because waiting longer means consuming more. The assertion made at the time by the architects of TXL—that they wanted to "humanize the necessary handling machinery through design"—thus appears all the more convincing.[7] A more humane airport than TXL has yet to be built.

A Monument of Innocence

This is an airport that completely lacks the overwhelming effects of today's spectacle-based architecture. Even in 2020, in its worn-out condition, the airport is a joy to walk through. Of course, some elements have gone missing here and there. The hexagonal red-brown brick pavement on the floors has been removed, for instance—its deep grooves were difficult to clean and formed serious tripping hazards for the wheeled suitcases that came into fashion. And the quiet clarity of the guidance system, which has remained completely intact, suffers from the advertising that is now all-too-shrill and omnipresent. And yet: the building still has something to say. Even more now than before, the changes that civil aviation has experienced over the last forty years can also be read in Tegel—starting with the repeatedly tightened security measures, with which TXL cannot cope. "Back then, nobody imagined that one day there would be hijackings!" said Meinhard von Gerkan in an interview in 2012.[8] Landshut, Lockerbie, and 9/11—that was hard to imagine in 1974. Equally hard to imagine was the ever-increasing desire for consumerist uses of space, which went hand in hand with safety regulations. Tegel's resolutely decentralized concept was not up to the task of dealing with these forces, which today result in huge centralized handling facilities at all airports around the world. The same can be said about the requirements for airports that function as a transfer station for connecting flights. Tegel is instead what railways used to call a terminus, or terminal station.

This can hardly be converted. TXL stands at odds to these global, terrorist, and capitalist developments—as a monument to a time that was so much more innocent. This makes experiencing the old airport all the more impressive. But what will remain of all that when TXL is converted into Beuth University's Urban Tech Republic after 2020? When the airplanes stop landing? Or when the control tower is turned into a climbing tower, as is planned, and the short distances within these brilliantly functional buildings finally become history?

What heritage value can the building have after it has been filled with research laboratories, work rooms, and lecture halls? A similar fate threatens other historic buildings from the same era

Welchen Denkmalwert kann das Gebäude dann haben, wenn Forschungslabore, Arbeitsräume und Hörsäle in ihm entstanden sind? Es droht ein ähnliches Schicksal wie anderen Erbgütern derselben Ära in Berlin: Das ICC und der Bierpinsel sind zwar beide erhalten, aber ihrer ursprünglichen Funktion und damit auch einer öffentlich zugänglichen Verständlichkeit beraubt. Verloren stehen sie in der veränderten Stadt, die nichts mehr mit ihnen anzufangen weiß und sie eher aus Ratlosigkeit denn aus Überzeugung erhält. Nein, wer die Flugzeuge aus Tegel wegdenkt, dem bleibt ein Gebäude von geringem Erkenntniswert. Nur wenn TXL als „kleiner Bruder" von BER und aktiver Flughafen in ein Gesamtkonzept des Berliner Flugverkehrs eingefügt würde, wonach es derzeit sicher nicht aussieht, wäre die Erhaltung von Terminal A vollumfänglich sinnvoll. Eine solche Entscheidung fiele allerdings aus heutiger Sicht in den Bereich der Wunder.

Spurensuche 2020 ff.
Sehr viel realistischer ist das Szenario, dass der Flugbetrieb am TXL bald nach Erscheinen dieses Buchs eingestellt sein wird. Und so bleibt das Erleben dieses einmaligen Flughafens dann Dokumenten überlassen wie den Fotografien Peter Ortners. Ihm ist es erstaunlich gut gelungen, die Spuren des Verfalls aus seinen Aufnahmen zu verbannen und viel vom eigentlich schon vergangenen Glanz der Anlagen – vom Terminal über das Hauptgebäude und die Auf-, Unter- und Umfahrungen bis zur Tankstelle – einzufangen. Peter und ich haben uns den Flughafen unabhängig voneinander erlaufen. Einig waren wir zwei Spurensucher uns schnell in unserer Begeisterung

für das Gebäude, dessen würdevolle Schönheit noch immer aus der radikalen Klarheit seiner räumlichen Organisation und aus den nachvollziehbaren Strukturen seiner alles verbindenden Geometrie besteht – trotz oder gerade wegen der Spuren jahrzehntelangen Gebrauchs bei mangelnder Pflege und Wartung. So sind wir in TXL gewesen und haben die wohl letzten Tage eines immer noch genialen Gebäudes im Betrieb miterlebt, das als Zeitzeuge so viel zu erzählen hatte – ein Ganzes, das weit mehr war als die Summe seiner Teile.

Florian Heilmeyer ist Architekturjournalist, Buchautor und Kritiker. Er lebt und arbeitet in Berlin.

1 Engelbert Lütke-Daldrup, zitiert nach „Berlin-Tegel-Sanierung würde eine Milliarde kosten", dpa-Meldung, in: Berliner Zeitung, 25.7.2017
2 Meinhard von Gerkan, zitiert nach „Weihe nach Wehen", in: Der Spiegel, 42/1974, S. 176
3 Robert Grosch, zitiert nach Manfred Sack, „Ein Halleluja für zwei Architekten", in: Die Zeit, 25.10.1974
4 „Platz für alle", in: Der Spiegel, 24/1974, S. 38
5 „Weihe nach Wehen", in: Der Spiegel, 42/1974, S. 176
6 Manfred Sack, „Ein Halleluja für zwei Architekten", in: Die Zeit, 25.10.1974
7 Meinhard von Gerkan, zitiert nach „Weihe nach Wehen", in: Der Spiegel, 42/1974, S. 176
8 Meinhard von Gerkan, zitiert nach Tillmann Prüfer, „Wir dachten, es wird ein weltweites Vorbild", in: Zeit Magazin, 19.1.2012

in the former West Berlin: the ICC and the Bierpinsel, or beer brush, have both been preserved but deprived of their original function and thus also of being intelligible in a public way. They stand lost in a changed city that no longer knows what to do with them, and that keeps them as listed monuments more out of helplessness than conviction. No—imagining Tegel without the aircraft means being left with a building that hardly has any intellectual value. Only if TXL were to be integrated into the overall concept of Berlin's air traffic, as an active airport and the "little brother" of BER, only then would it make complete sense to keep Terminal A. From today's perspective, however, such a decision would be nothing less than a miracle.

Looking for Traces—In 2020 and Beyond

A more realistic scenario is that flight operations at TXL will be discontinued soon after this book is published. And the experience of this unique airport will then be left to documentations like Peter Ortner's photographs. He has been amazingly successful in banishing all traces of decay from his images and capturing a great deal of the now-faded splendor of the facilities—from the terminal to the main building, from the access roads, underpasses, and bypasses to the gas station. Peter and I walked our way to explore the airport independently of each other. In each searching for traces, we quickly came together to share our enthusiasm for the building, whose dignified beauty still lies in the radical clarity of its spatial organization and the comprehensible structures of the geometry that connects all of its elements—in spite or perhaps because of the traces left by decades of use with insufficient care and maintenance. This is

how we experienced TXL in what were probably its last days of operation as a building that remained so brilliant, and that had so much to say as a witness of its times—a whole that was far more than the sum of its parts.

Florian Heilmeyer is an architectural journalist, author, and critic. He lives and works in Berlin.

1 Engelbert Lütke-Daldrup, quoted from "Berlin-Tegel-Sanierung würde eine Milliarde kosten," dpa report, *Berliner Zeitung*, July 25, 2017
2 Meinhard von Gerkan, quoted from "Weihe nach Wehen," *Der Spiegel* 42 (October 14, 1974), 176
3 Robert Grosch, quoted from Manfred Sack, "Ein Halleluja für zwei Architekten," *Die Zeit*, October 25, 1974
4 "Platz für alle," *Der Spiegel* 24 (October 14, 1974), 38. "Teglitzer Kreisel" is a pun combining "Kreisel" (traffic roundabout) with a derogatory allusion to the Steglitzer Kreisel, a controversial high-rise in Berlin-Steglitz for which construction began in 1968.
5 "Weihe nach Wehen," *Der Spiegel* 42 (October 14, 1974), 176
6 Manfred Sack, "Ein Halleluja für zwei Architekten," *Die Zeit*, October 25, 1974
7 Meinhard von Gerkan, quoted from "Weihe nach Wehen," *Der Spiegel* 42 (October 14, 1974), 176
8 Meinhard von Gerkan, quoted from Tillmann Prüfer, "Wir dachten, es wird ein weltweites Vorbild," *Zeit Magazin*, January 19, 2012

Danke an Julia für die vielfältigen Inspirationen und die Unterstützung.
With thanks to Julia for her creative inspiration and support.

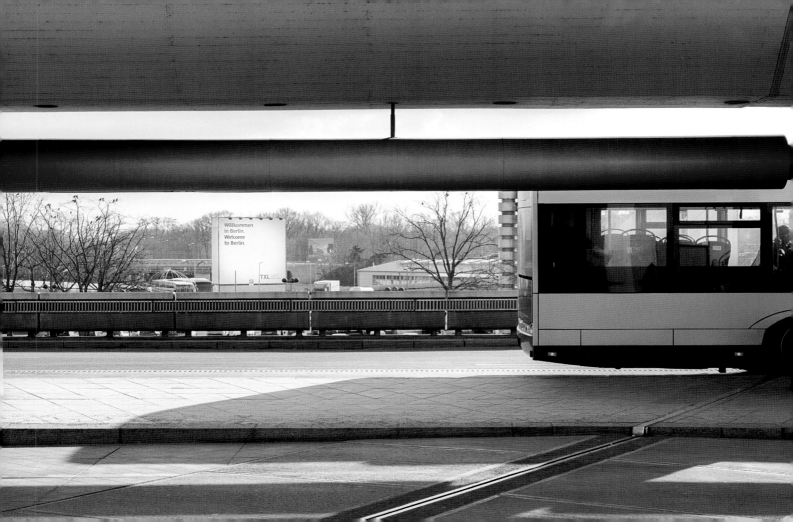

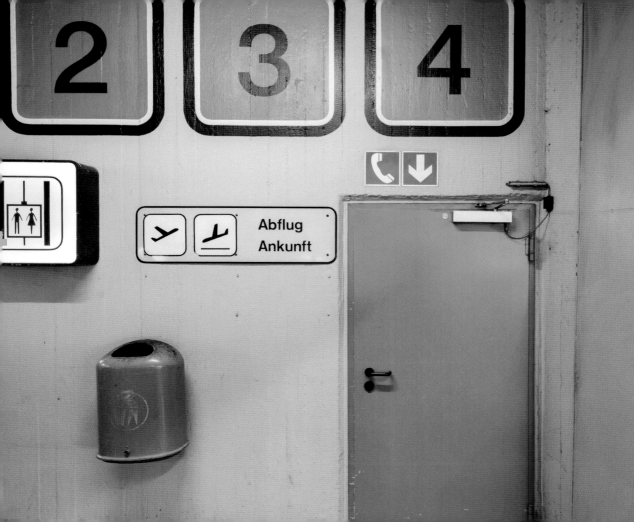

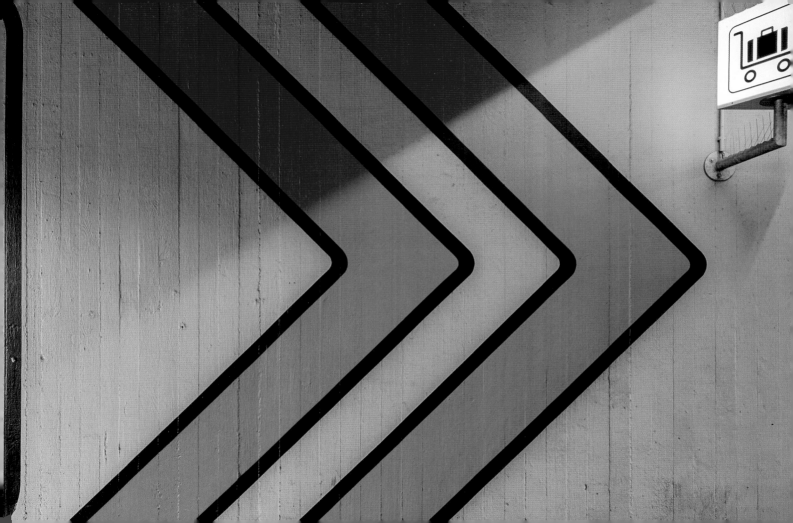

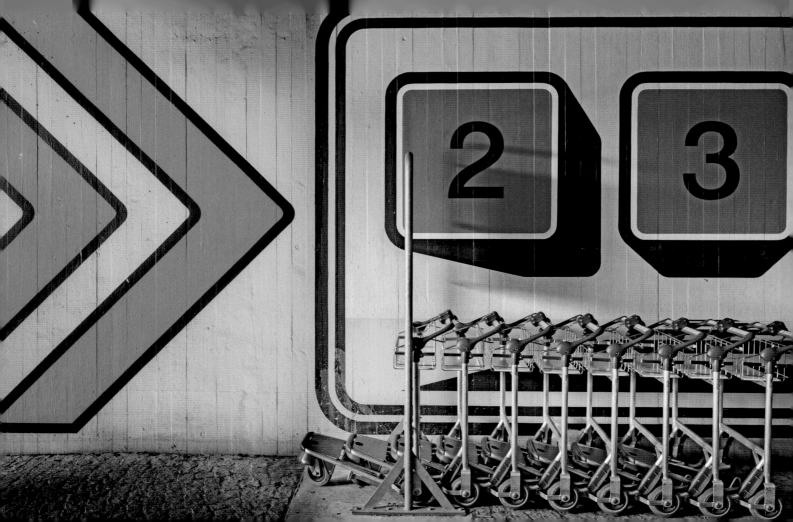

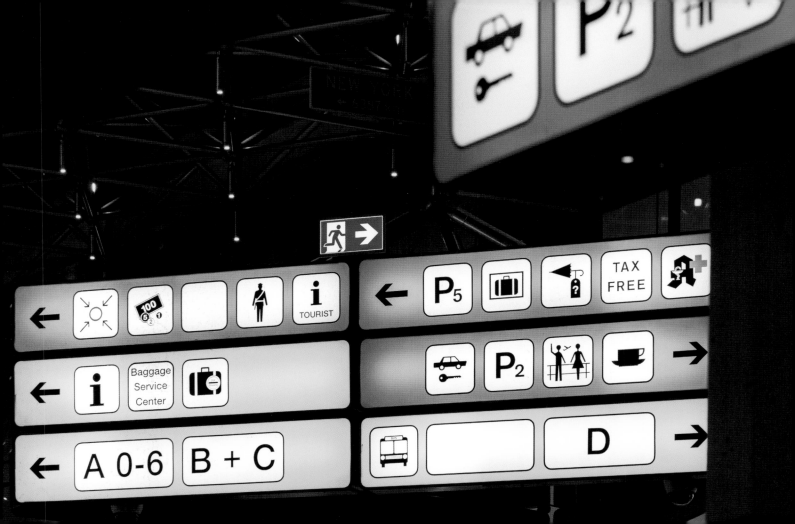

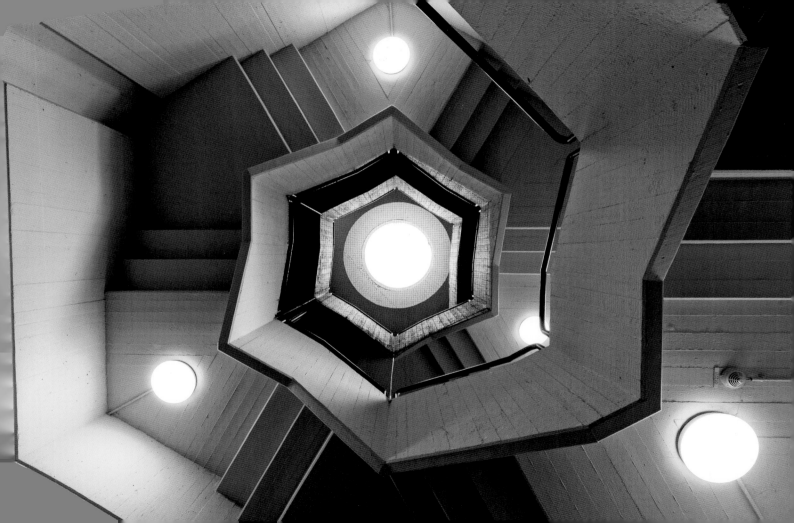

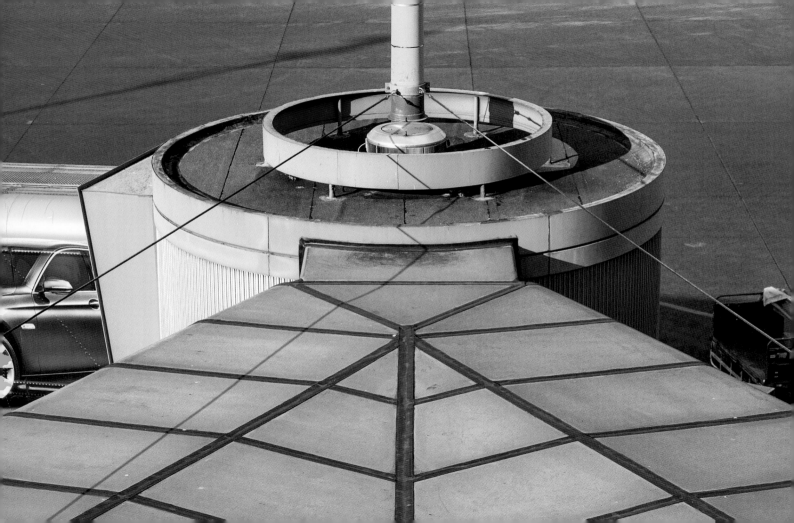

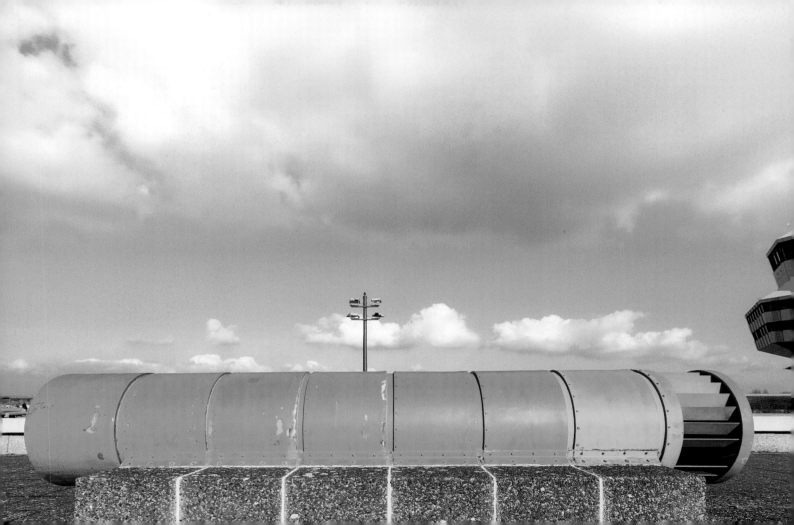

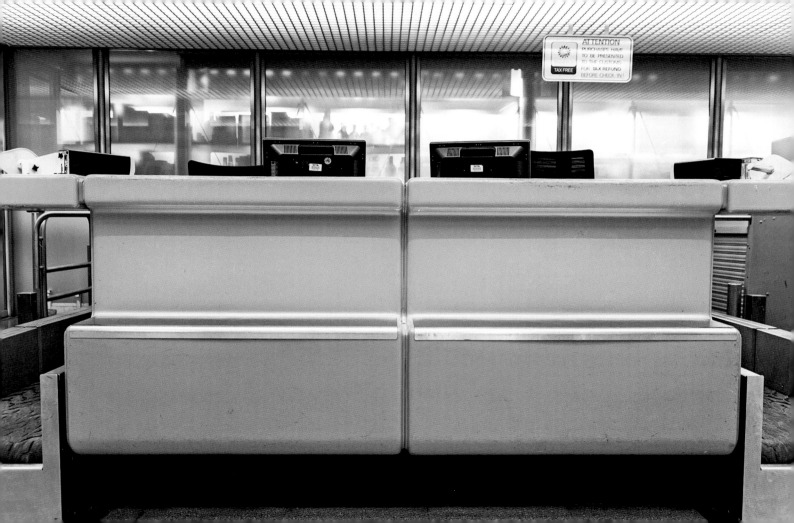

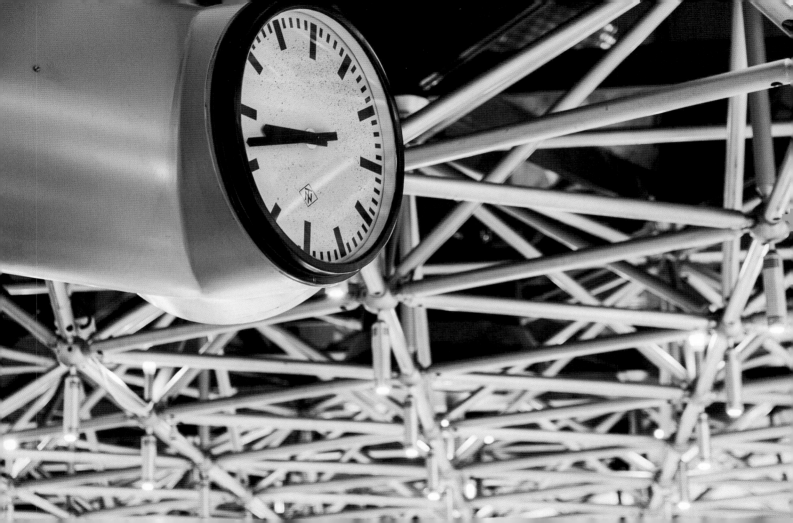

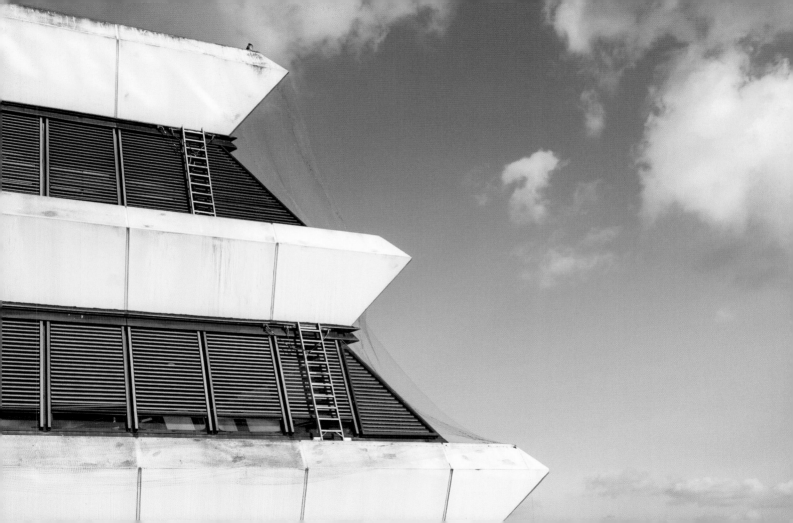

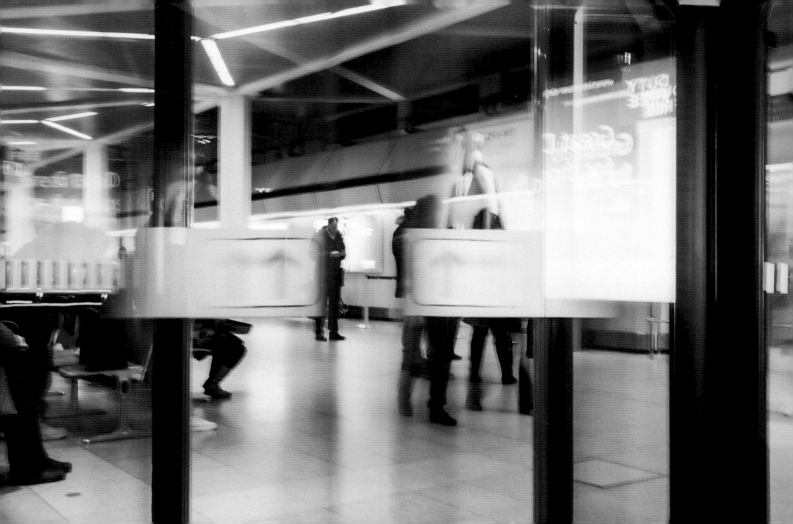

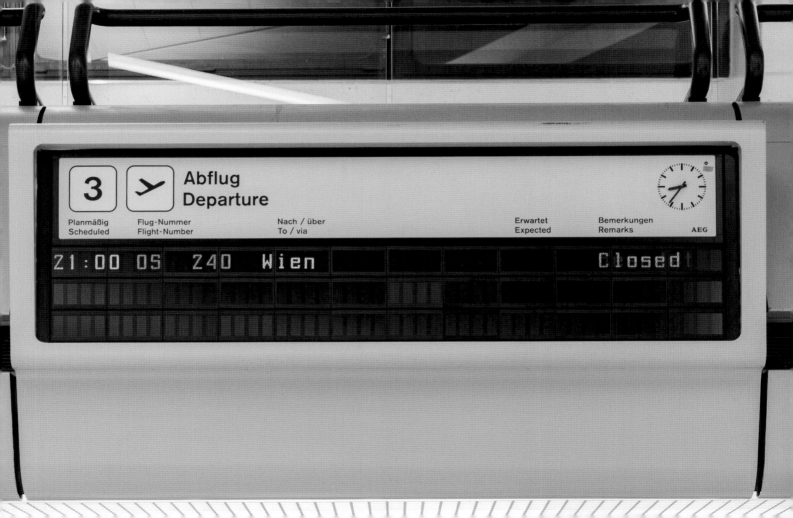

A 8-15	A 0-7
←	→
D + E	B + C

WEITERE FLUGANZEIGEN IM TERMINAL

FURTHER FLIGHT DISPLAYS IN THE TERMINAL

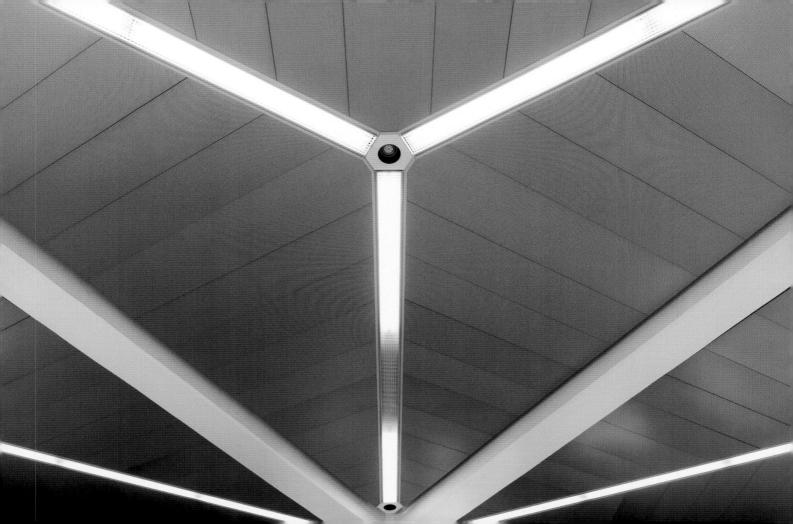

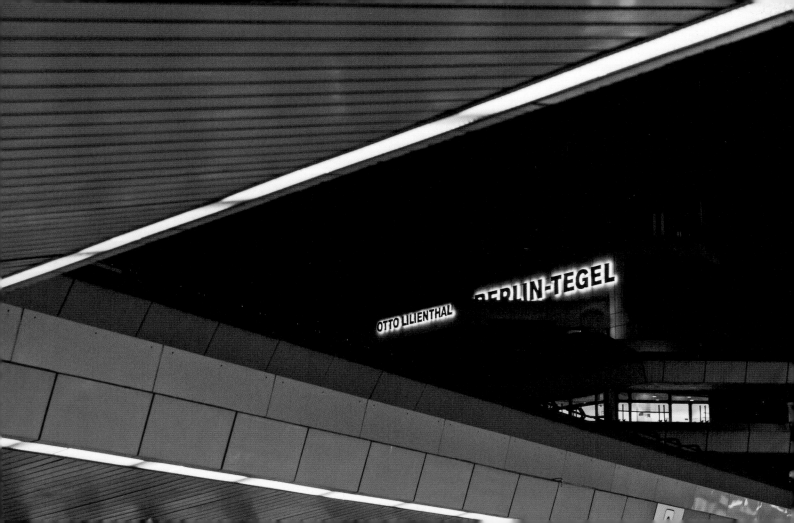

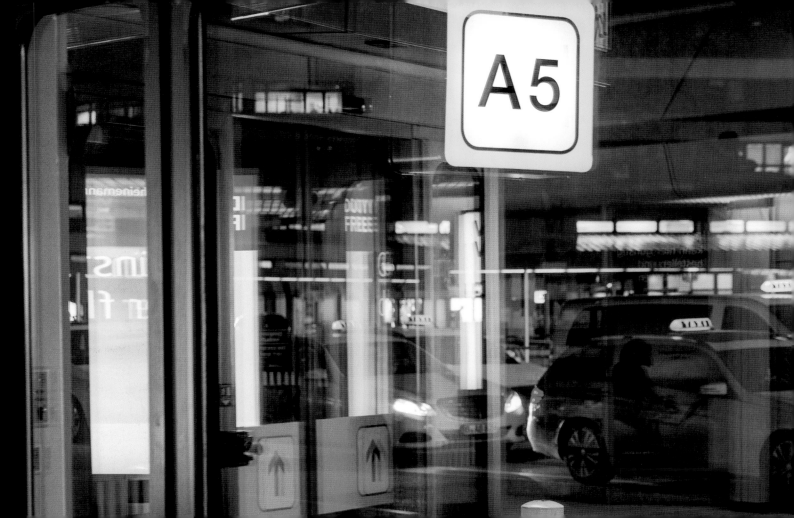

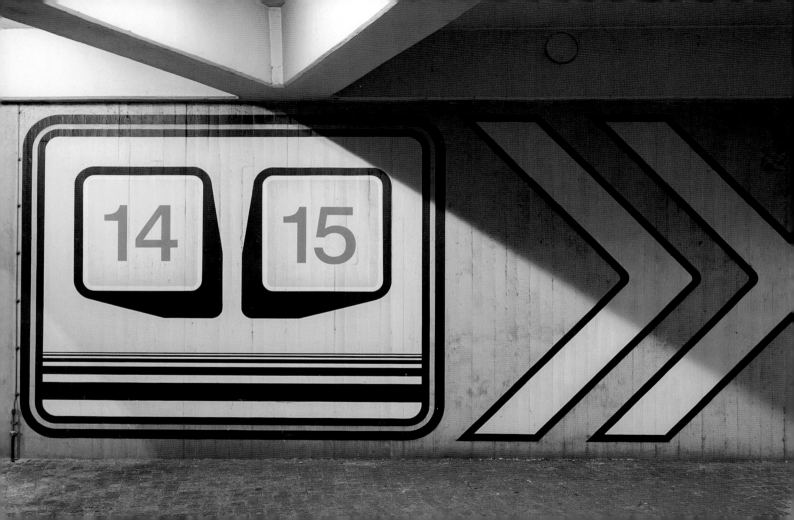

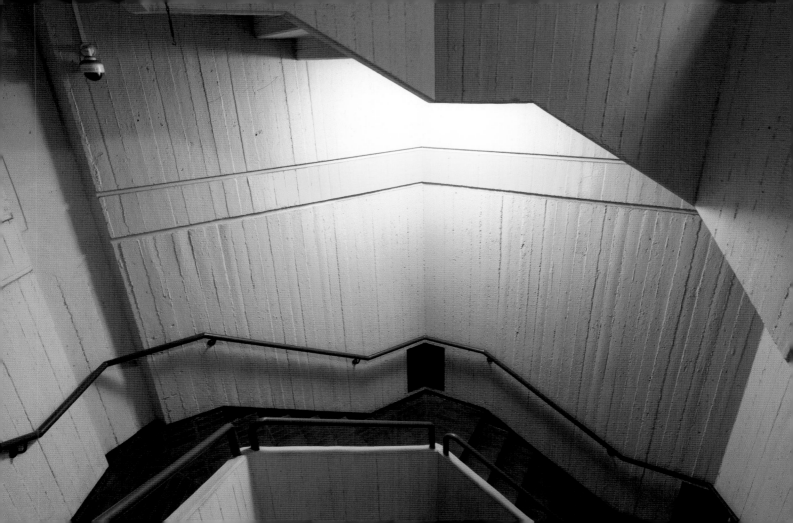

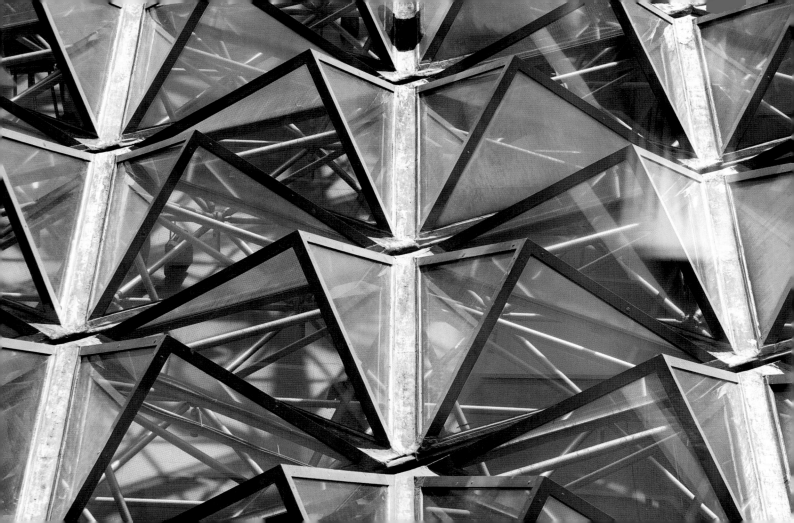

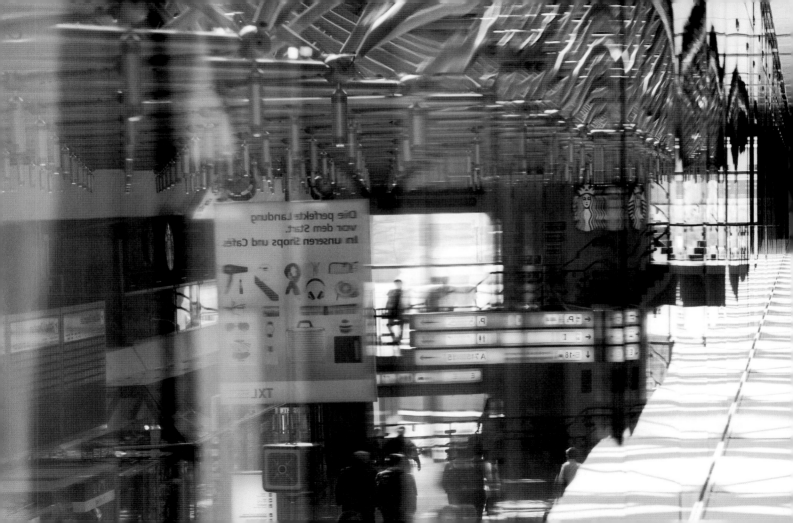

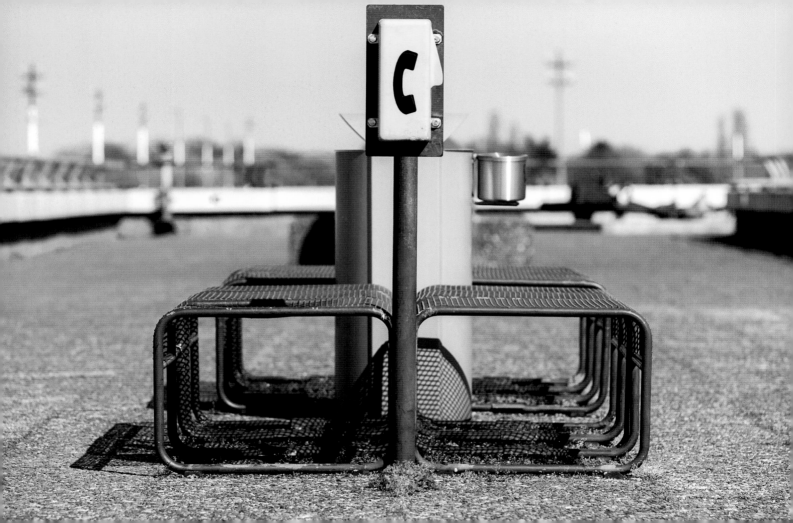

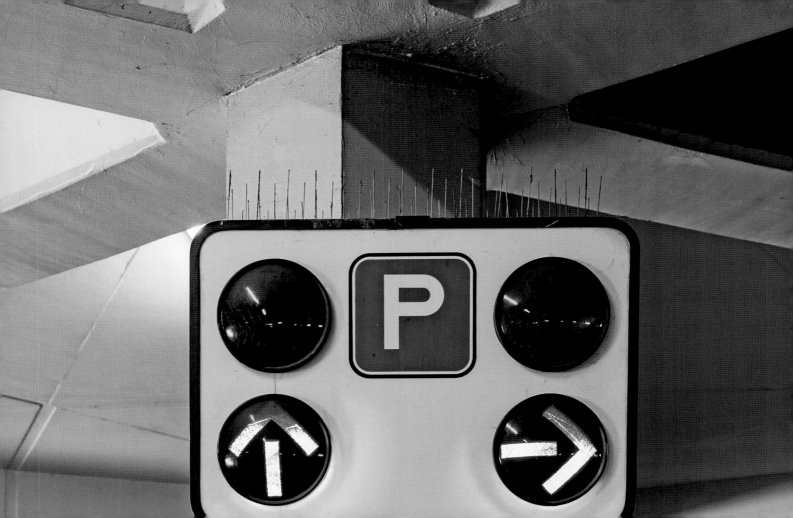

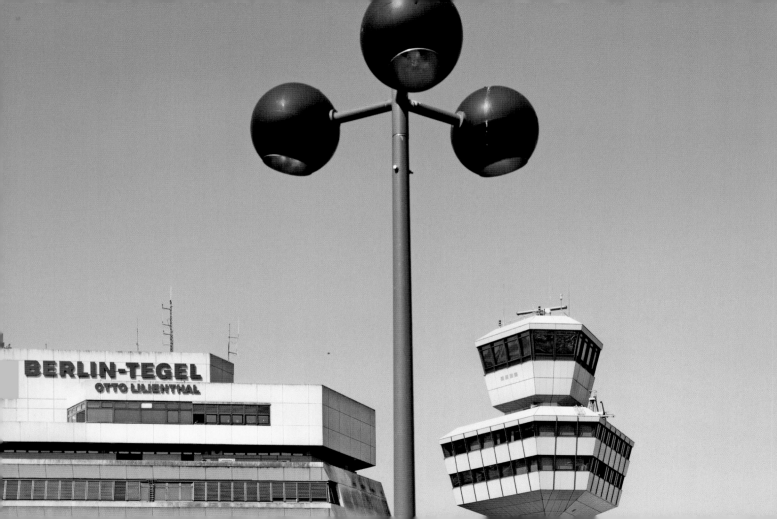

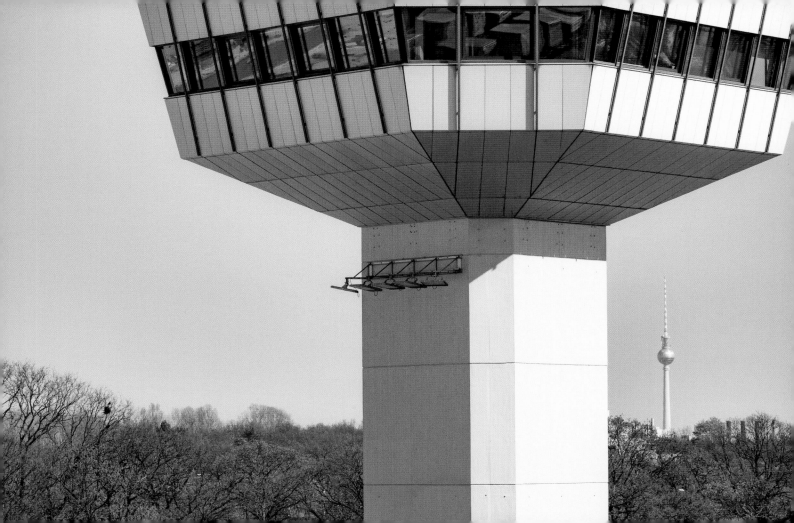

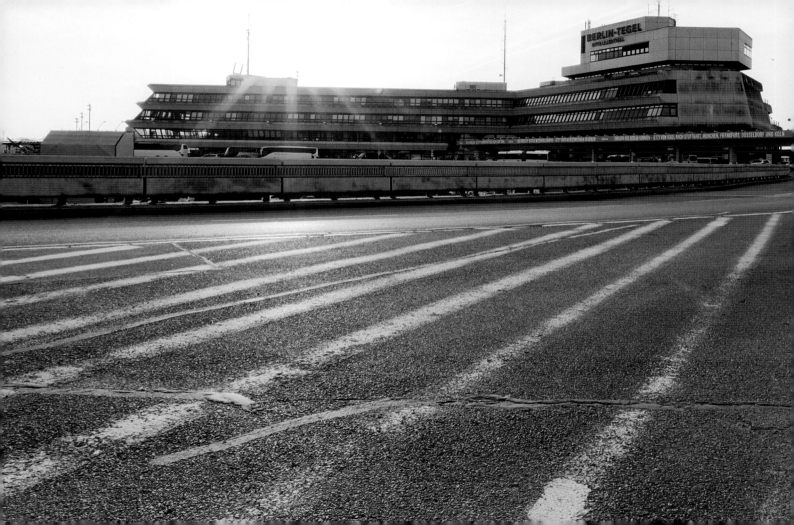

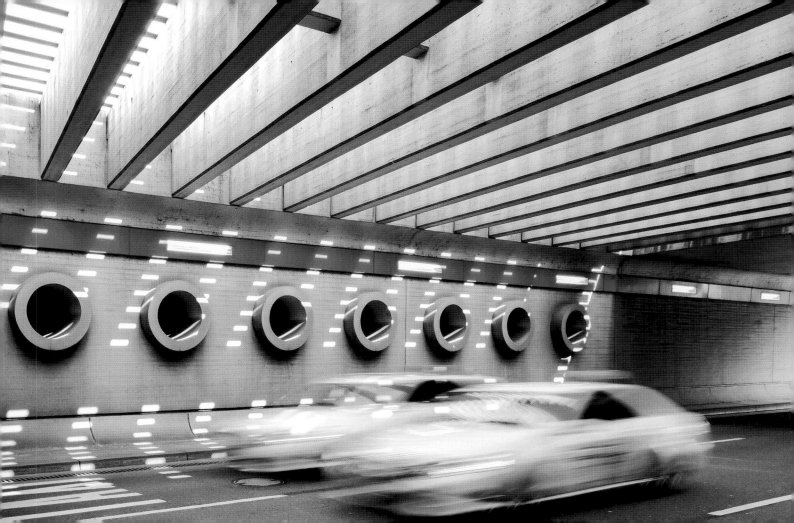

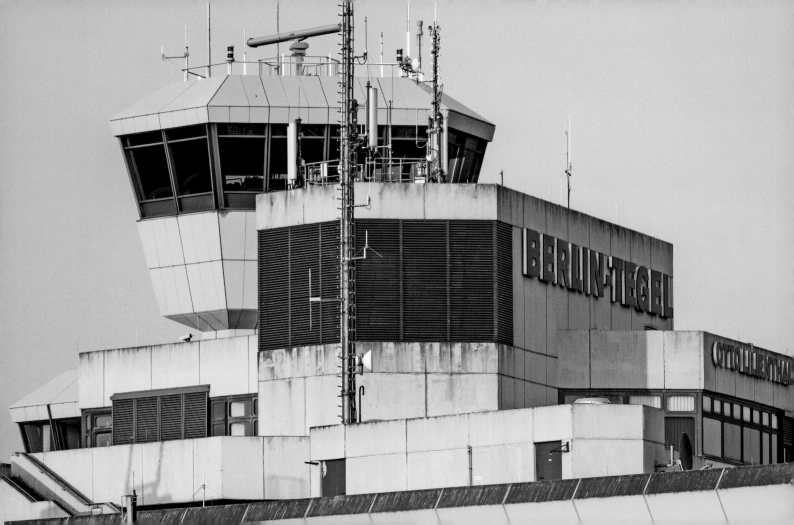

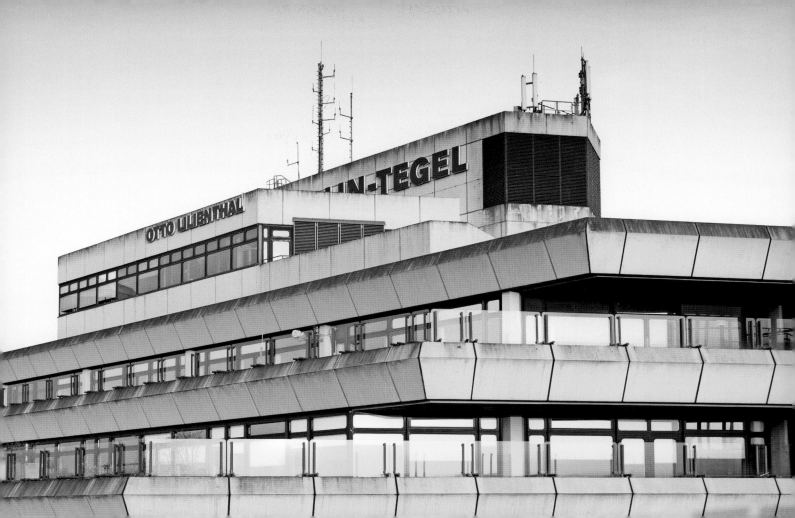

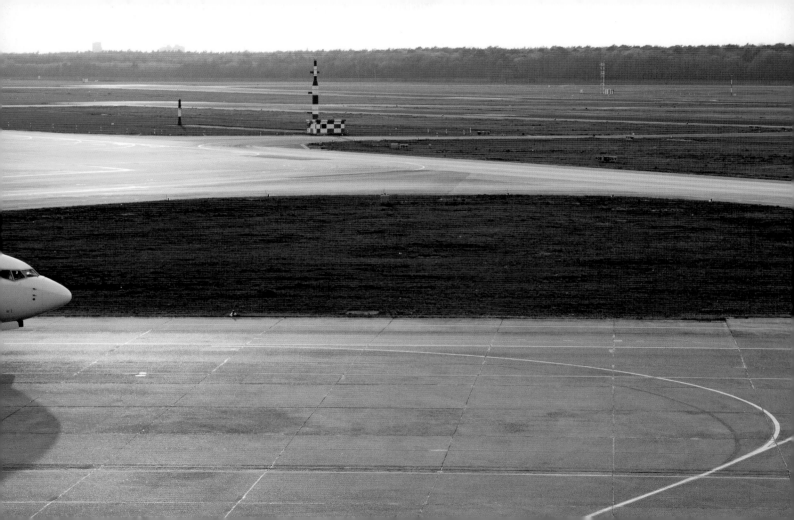

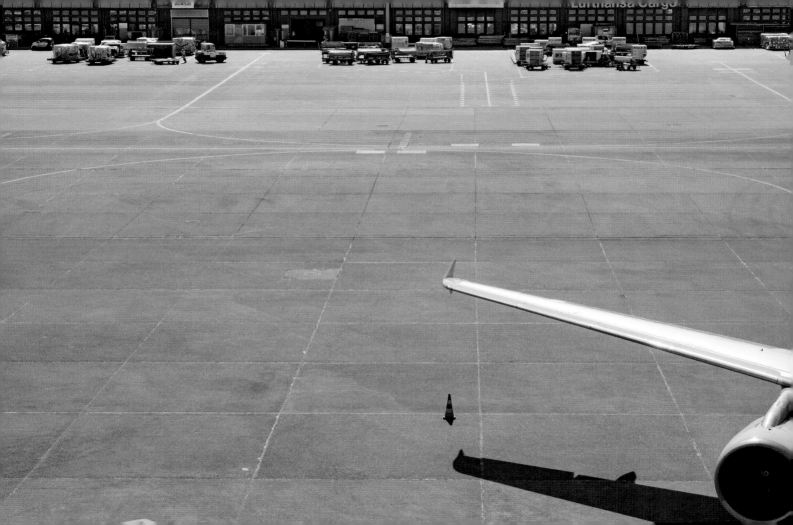

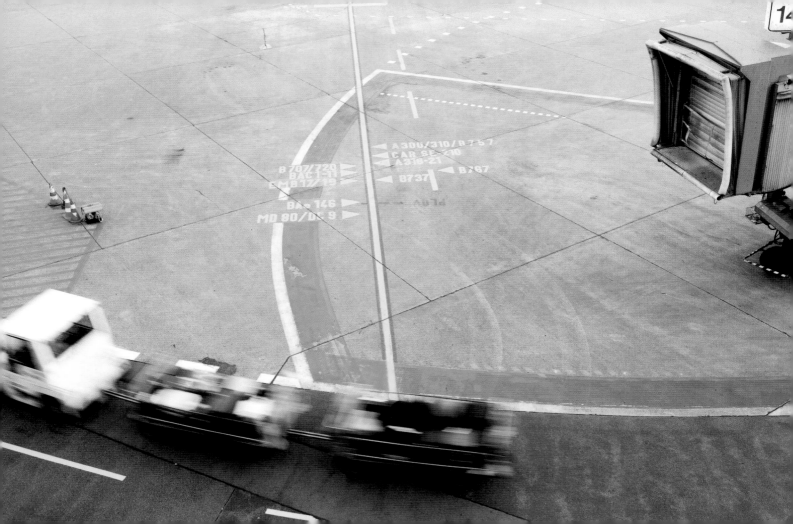

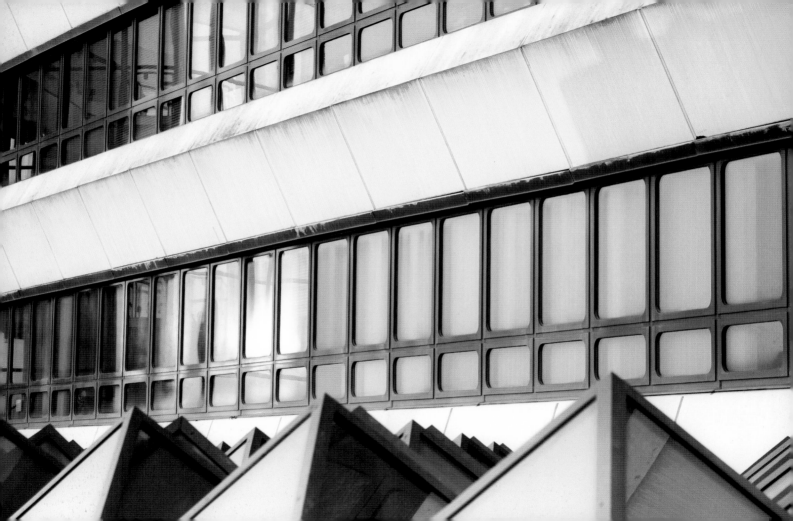

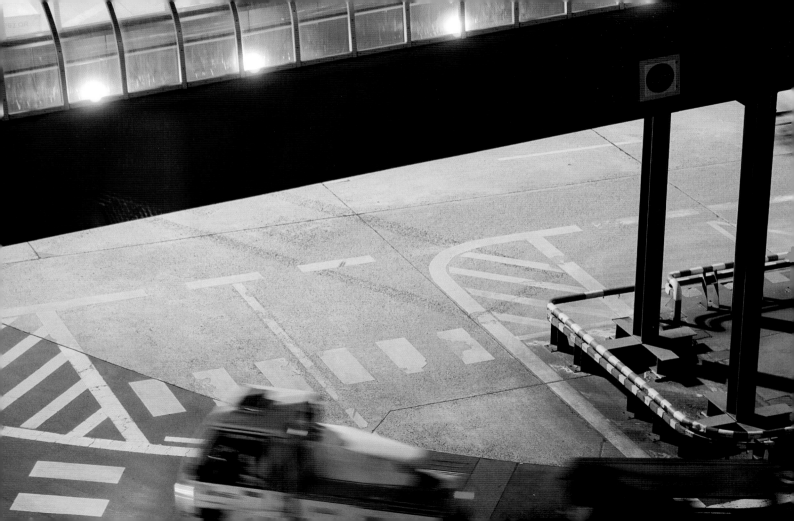

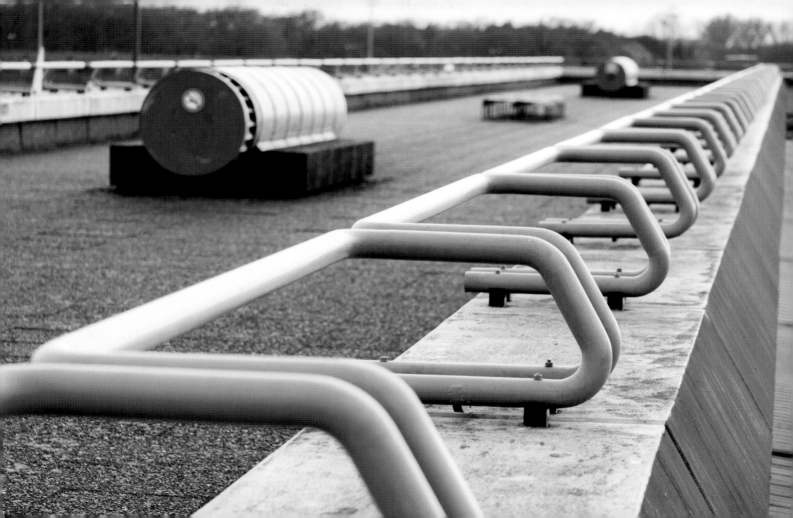

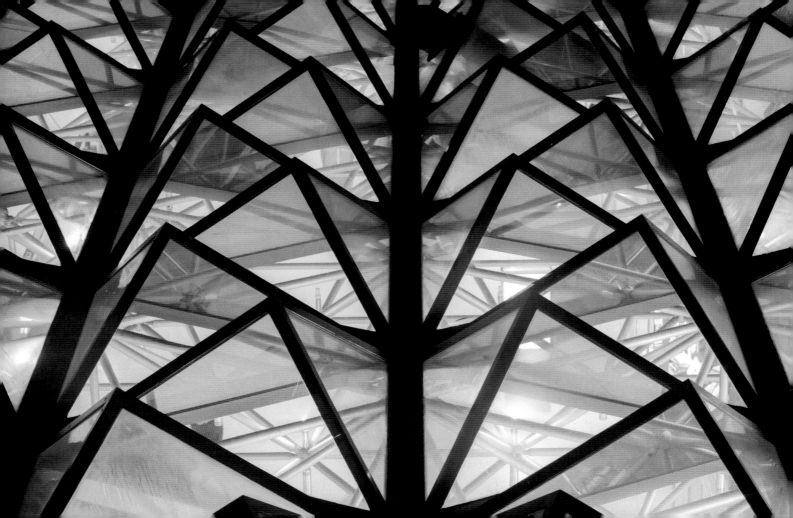

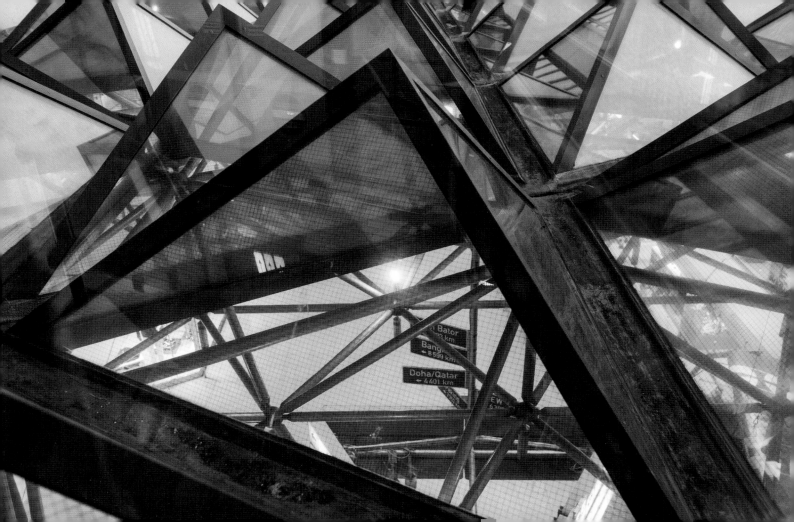

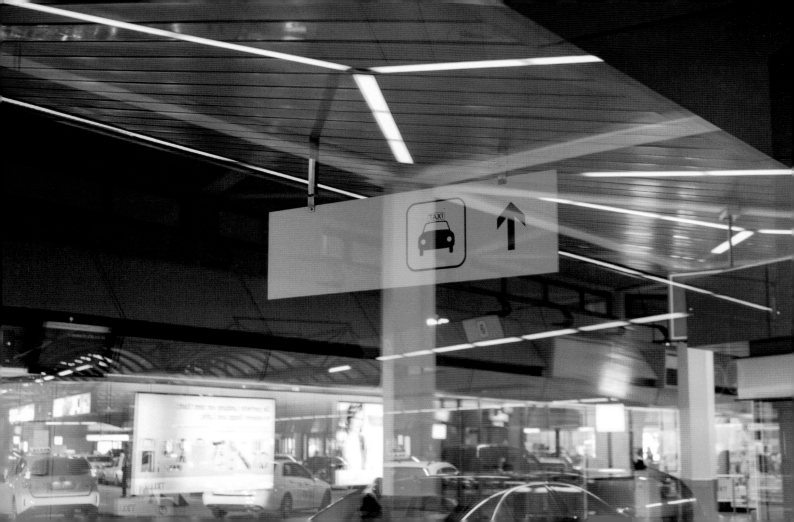

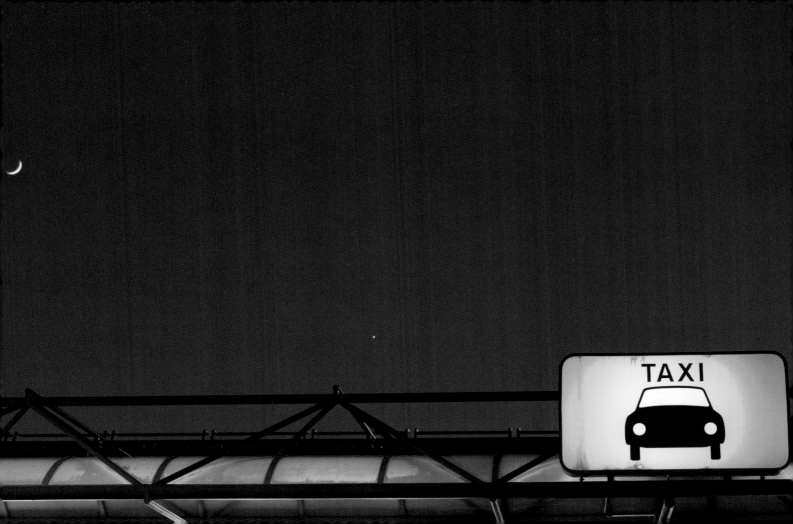

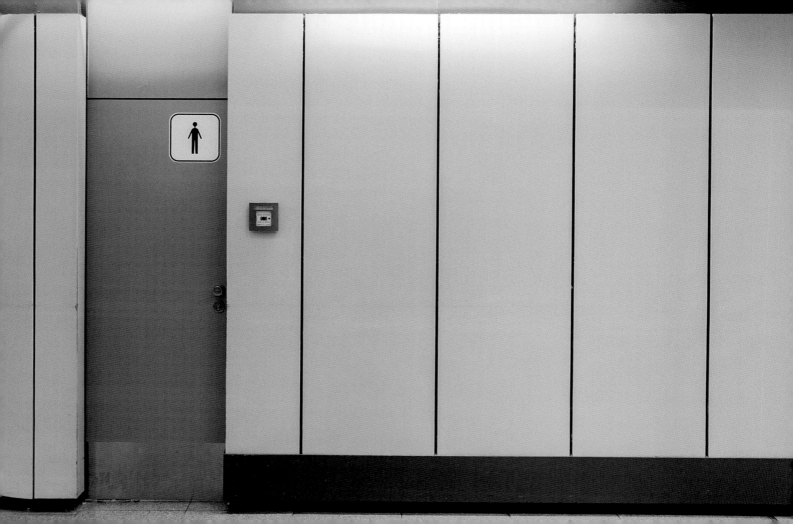

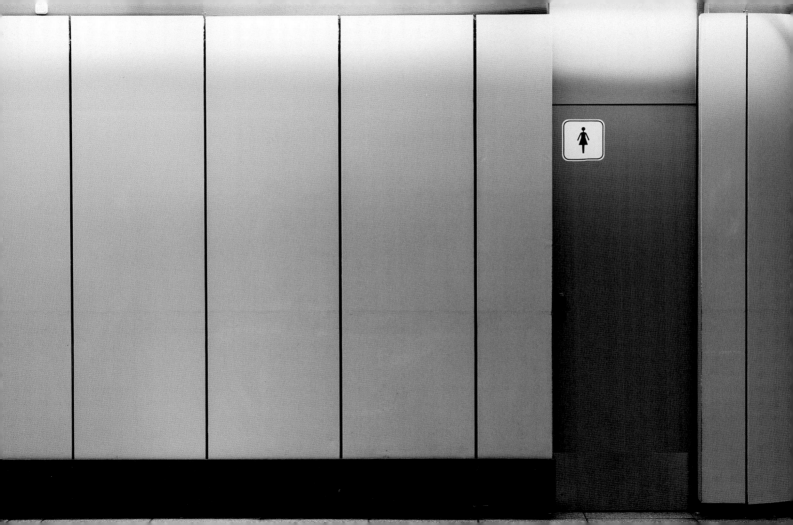

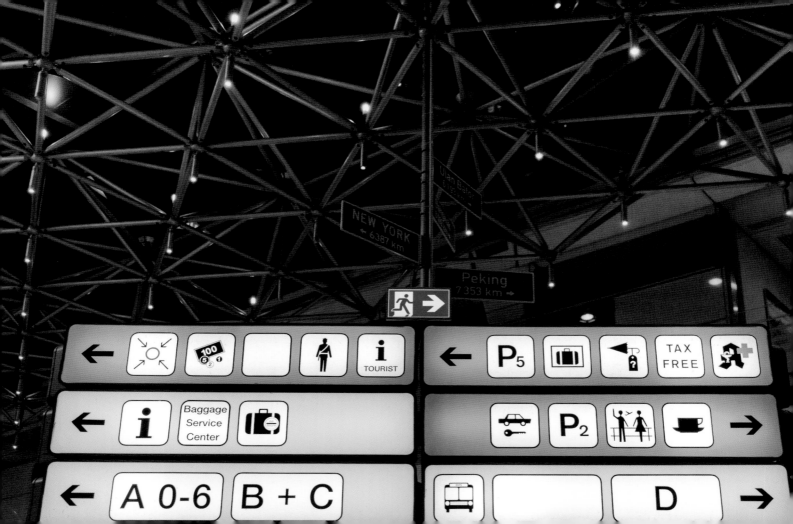

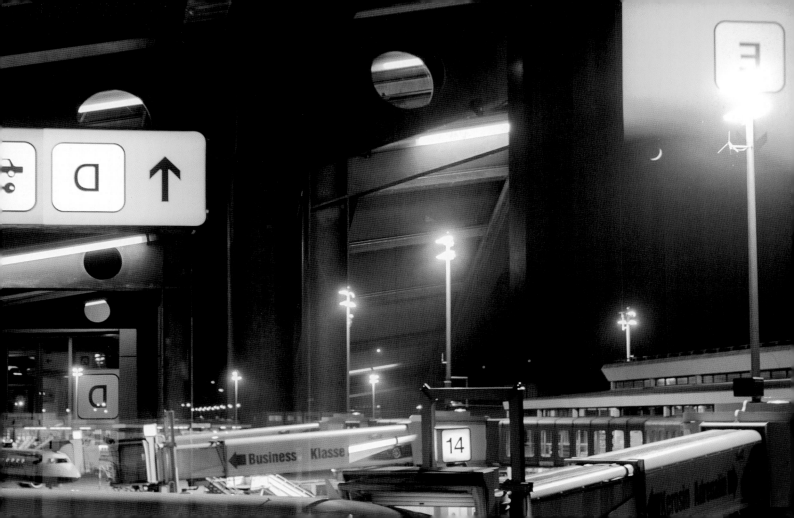

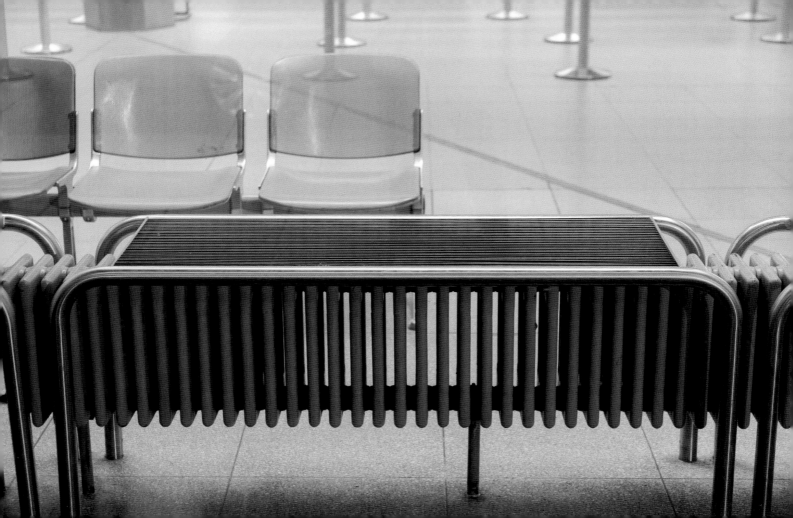

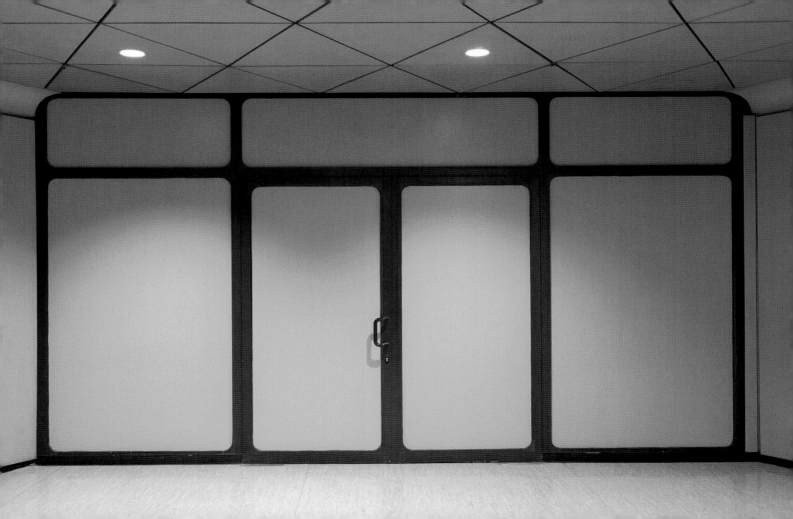

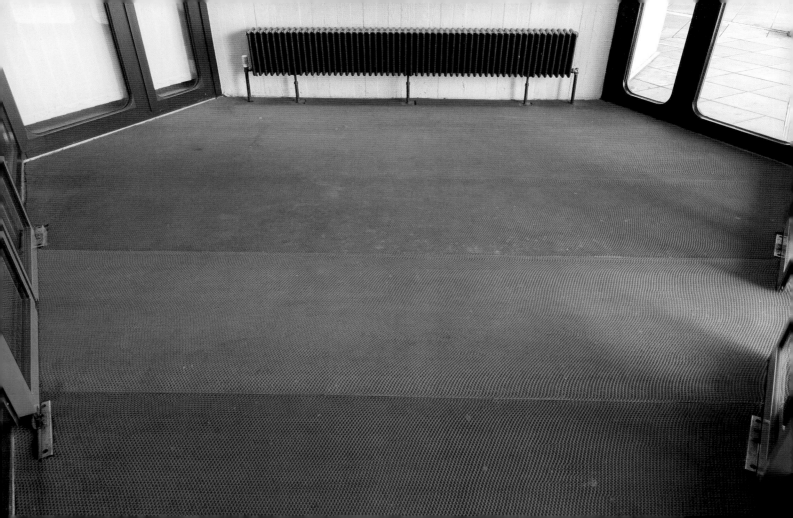

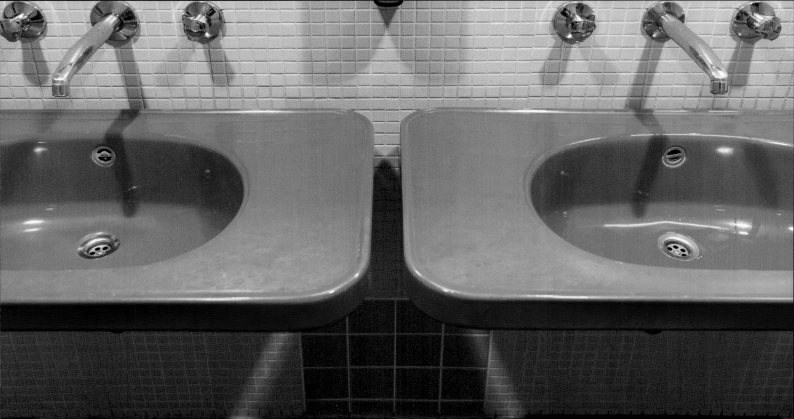

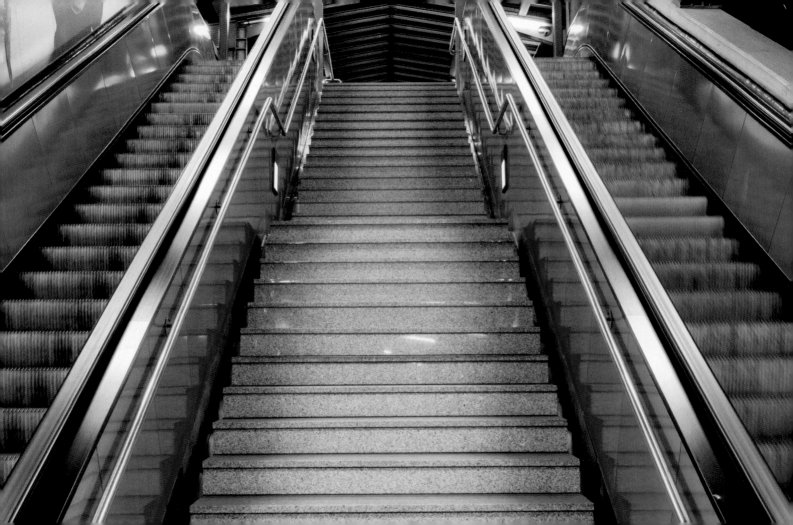

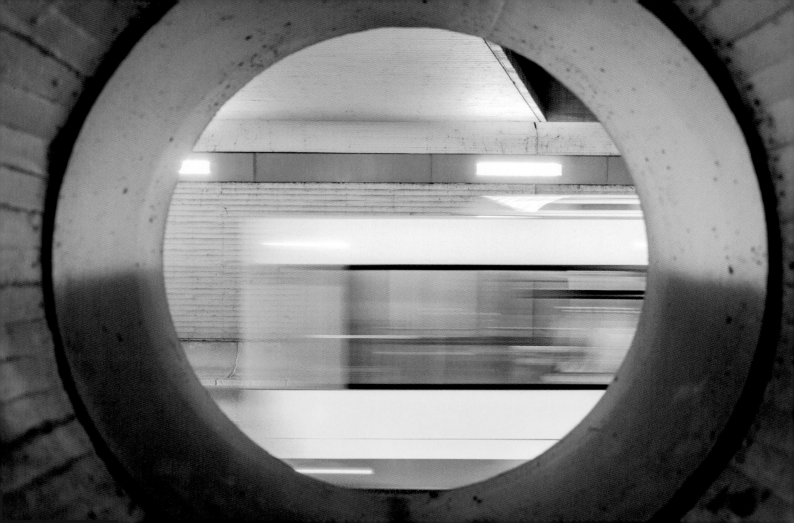

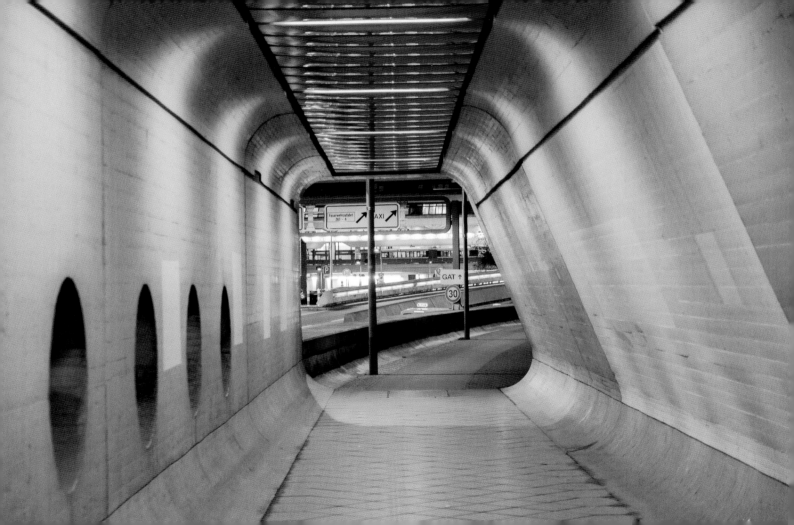

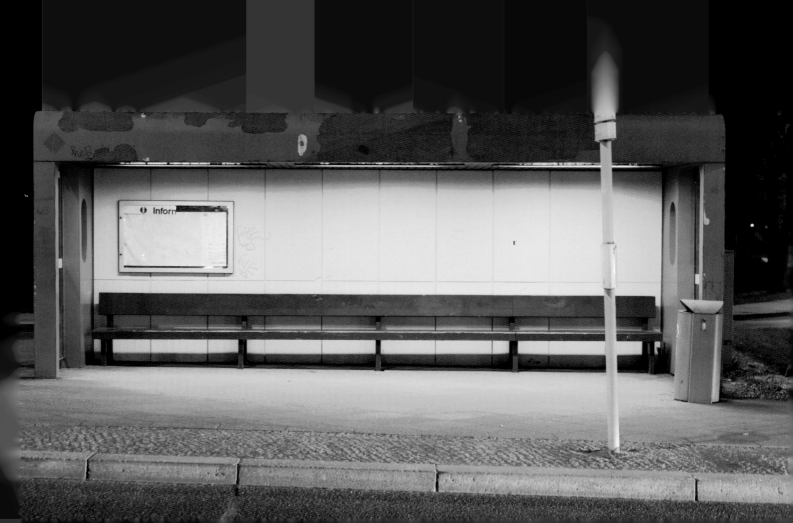

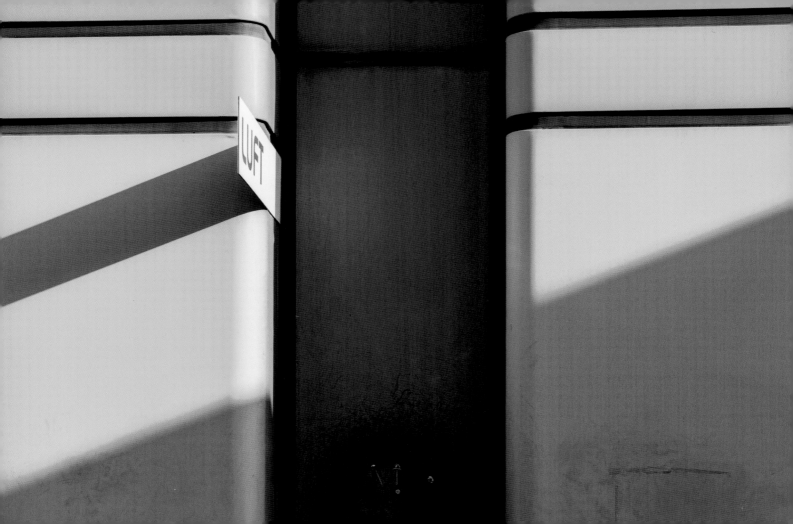

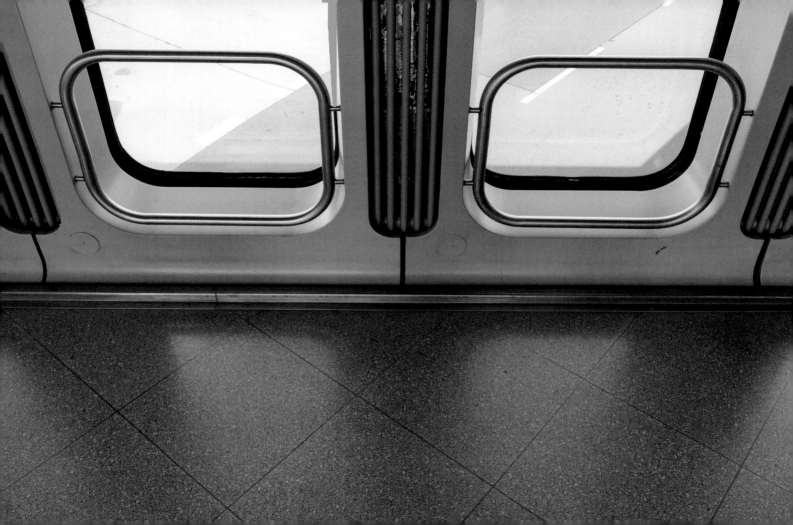

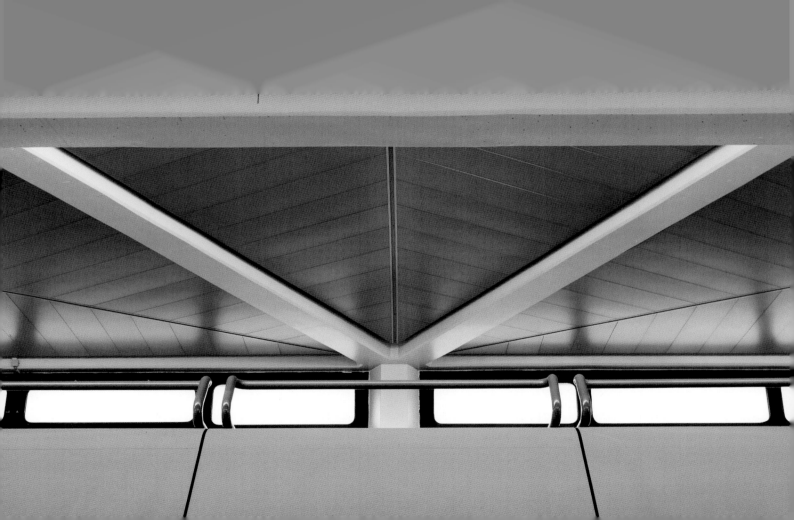

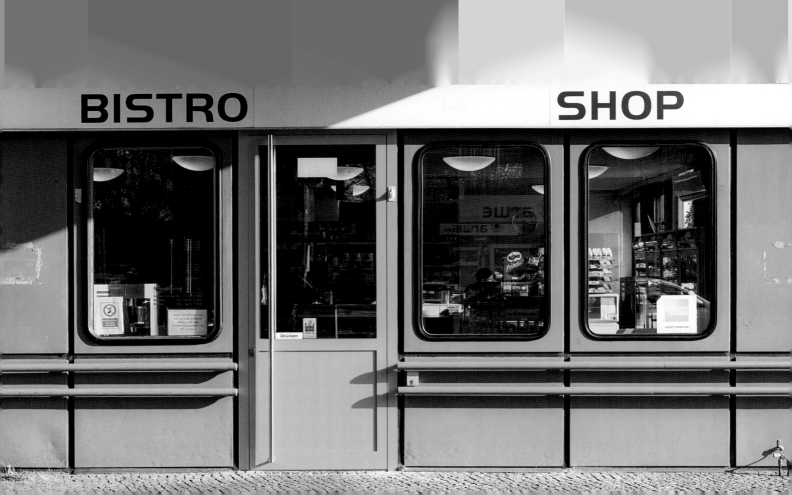

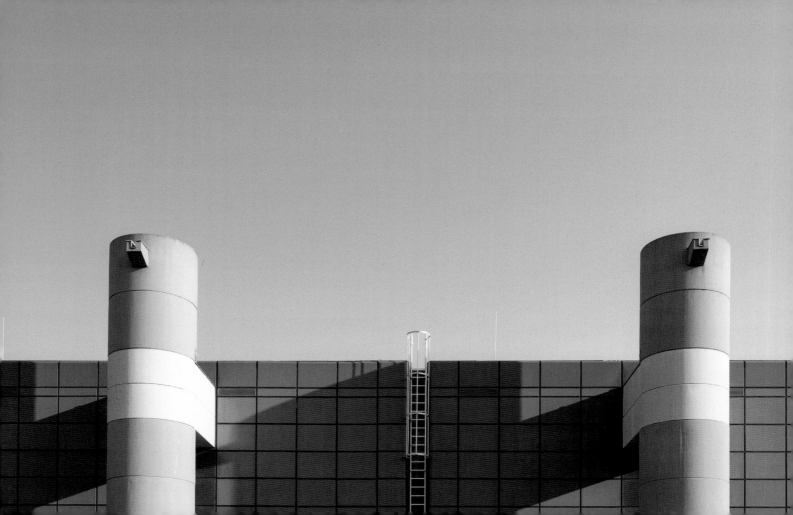

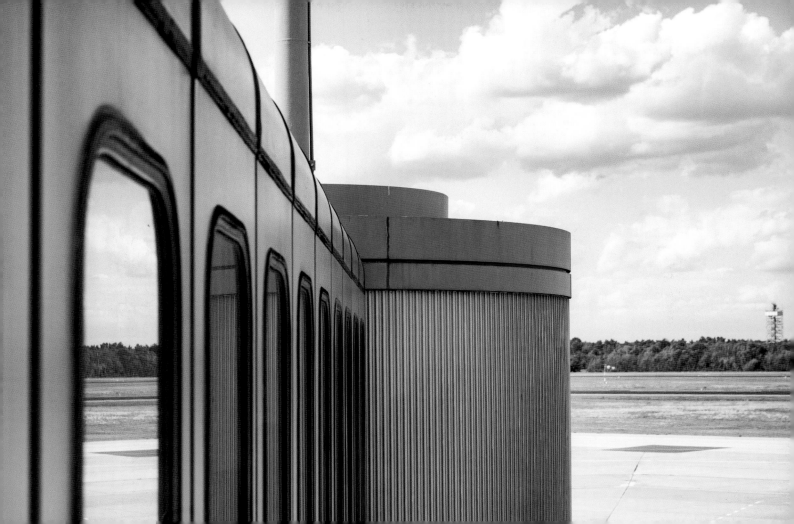

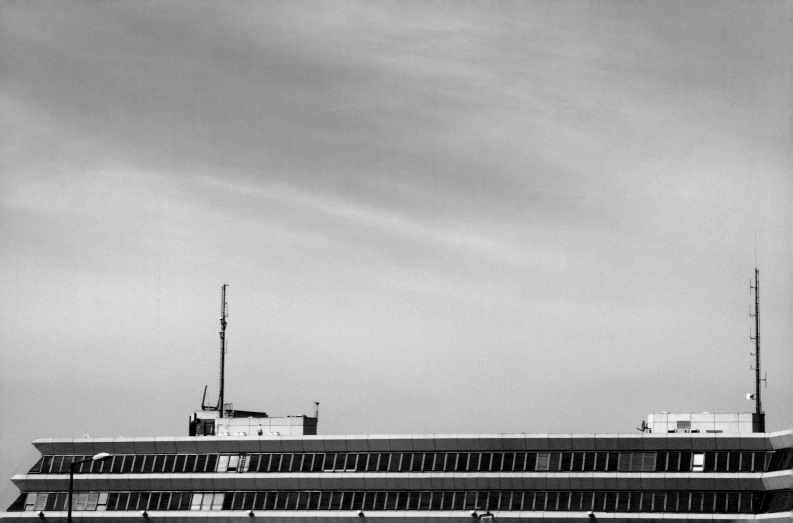

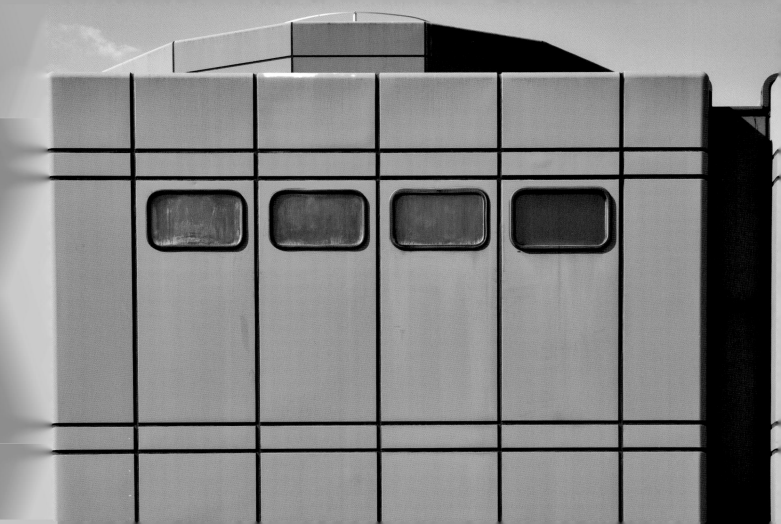

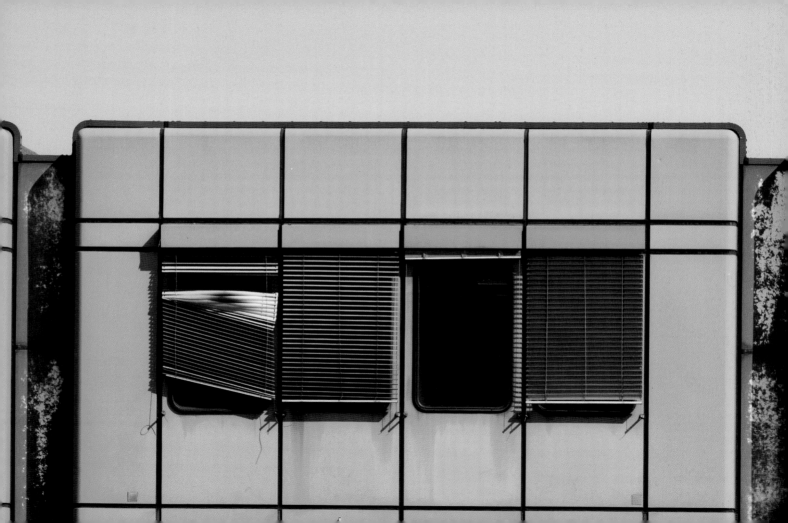

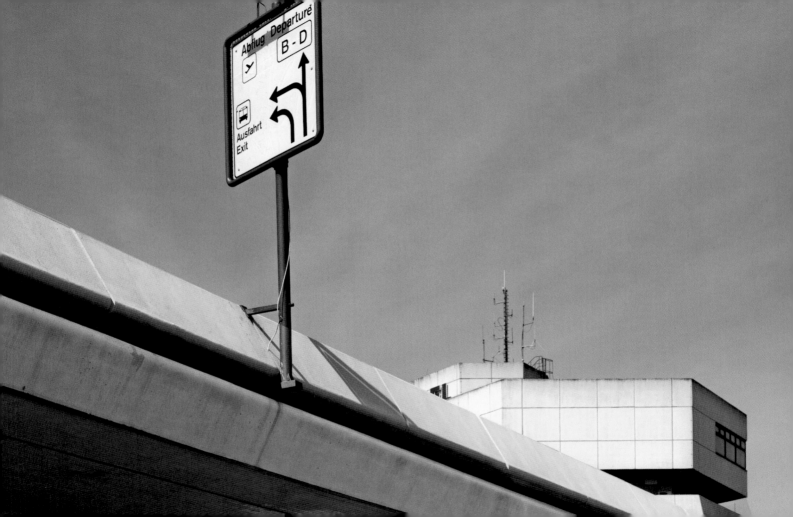

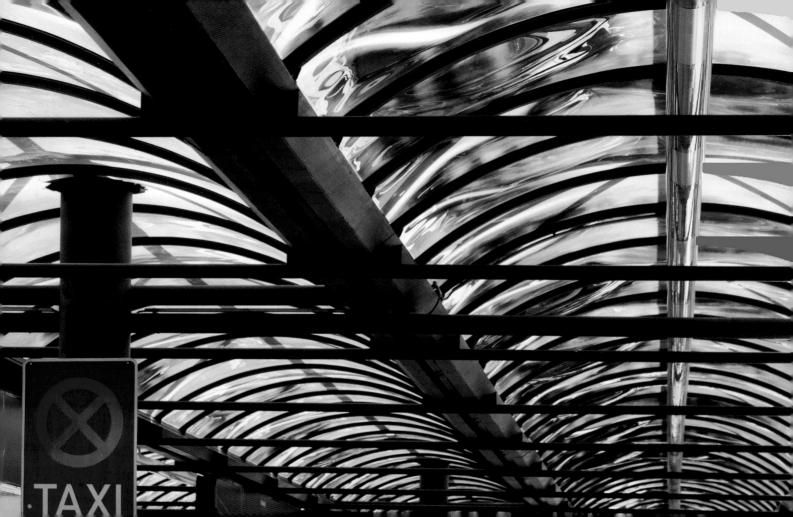

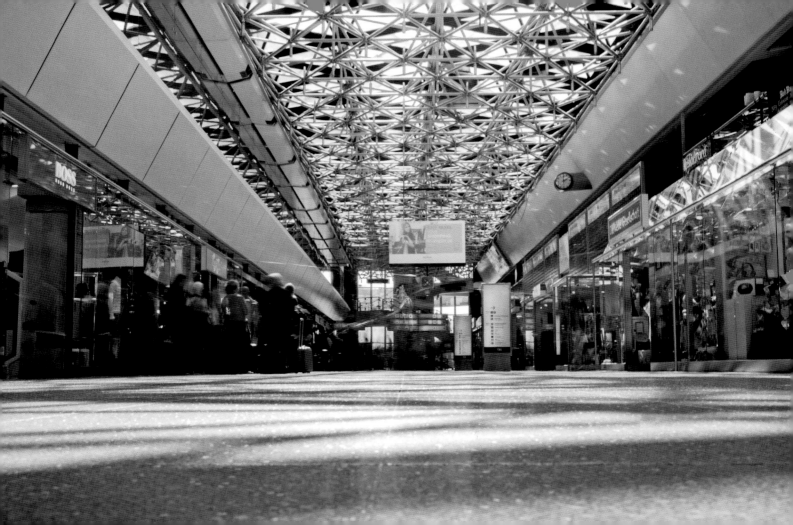

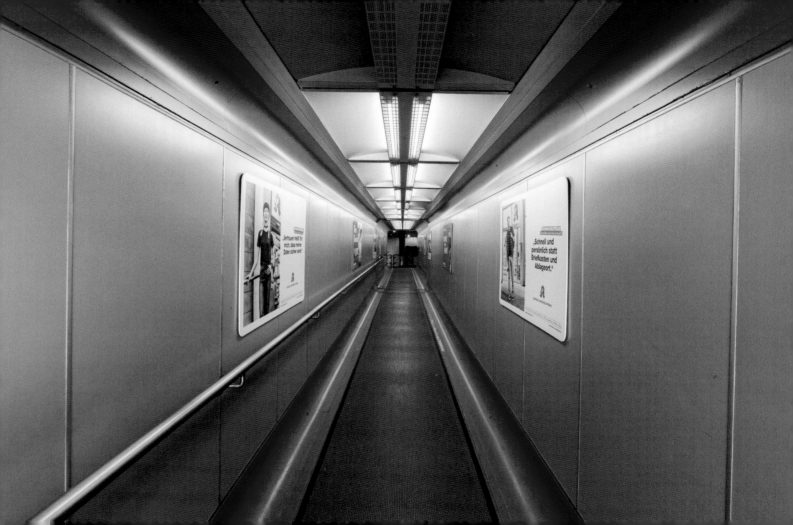

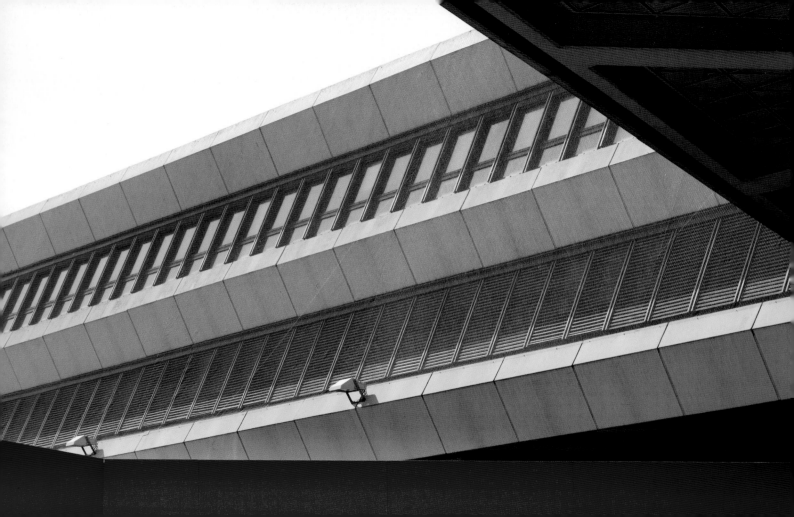

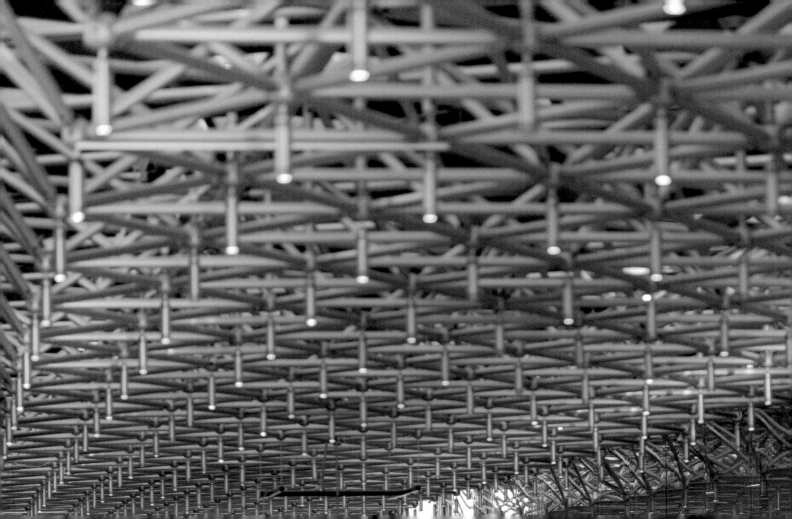

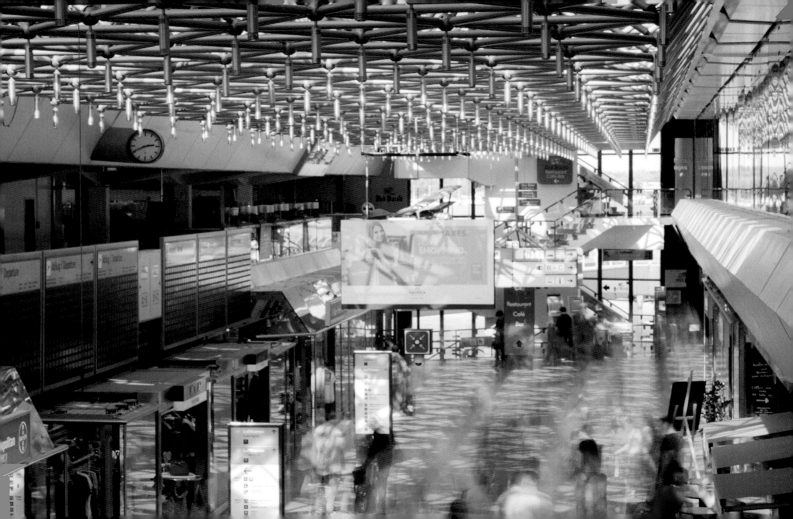

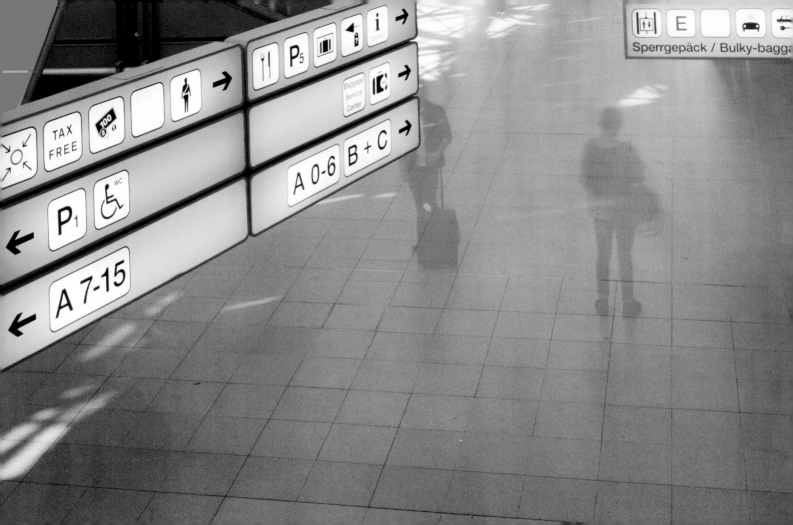

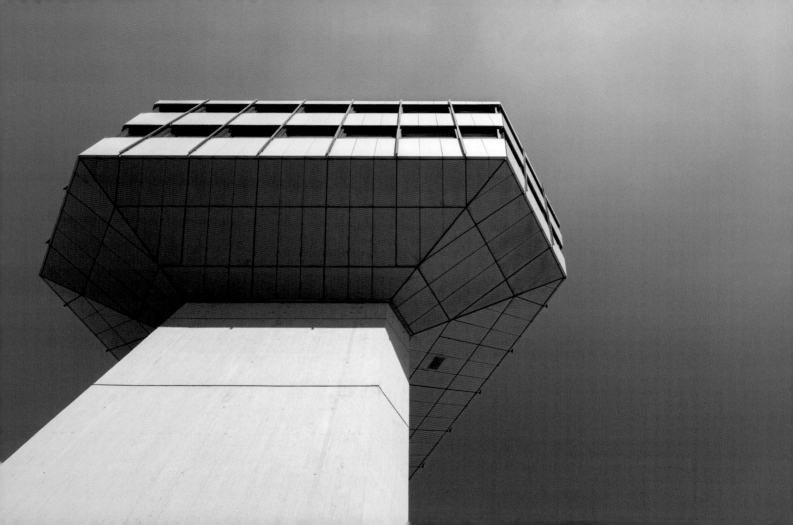

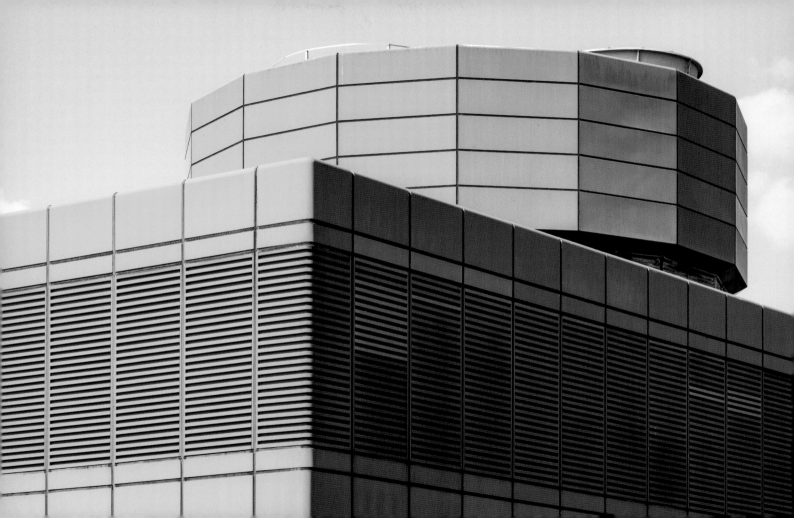

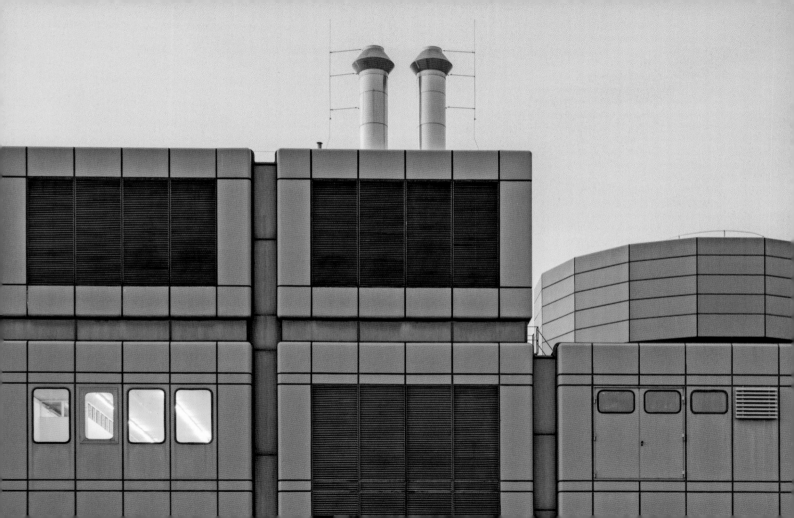

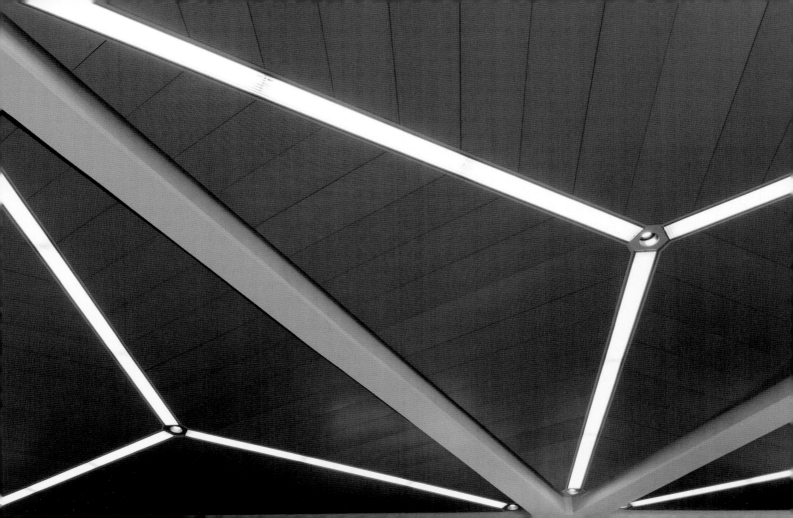

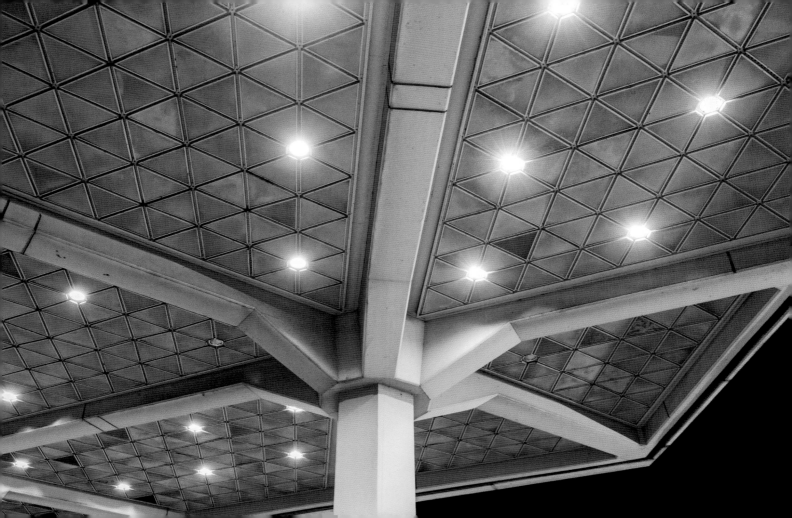

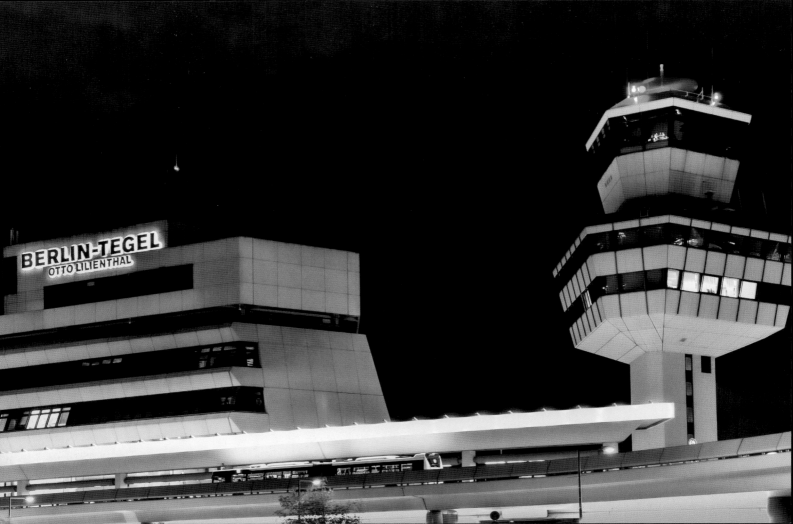

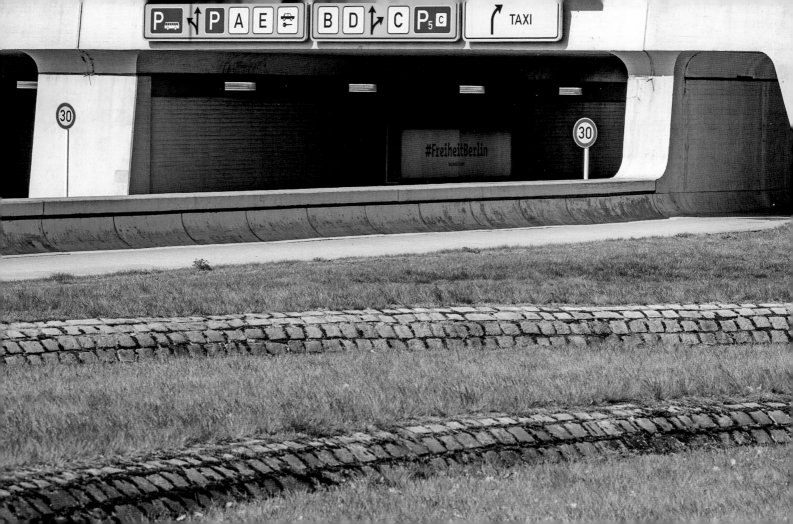

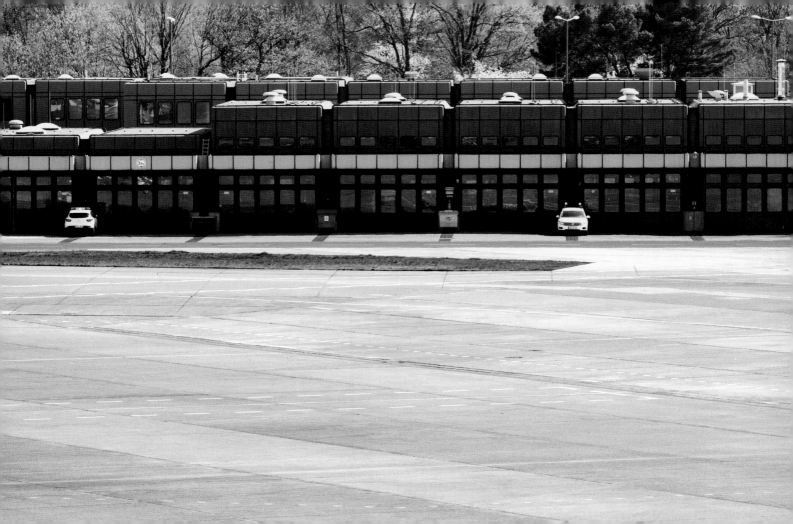

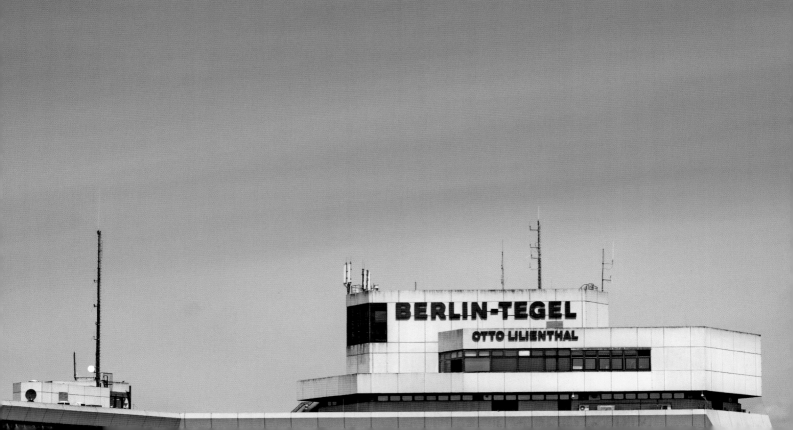

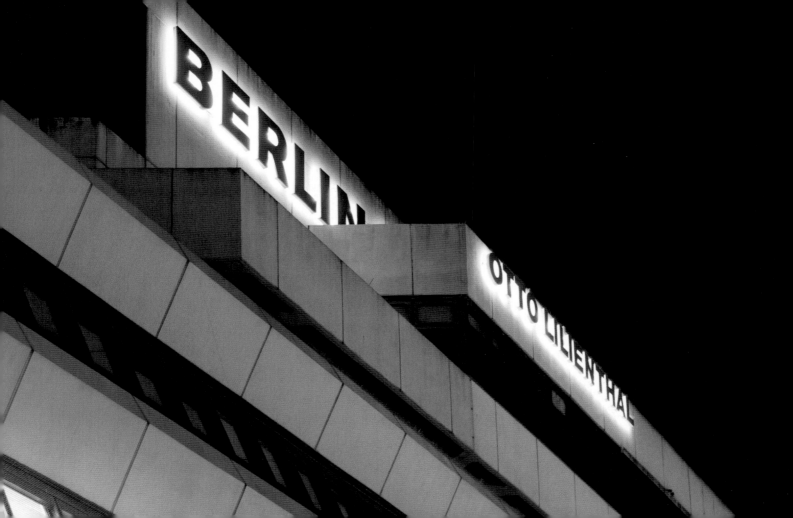

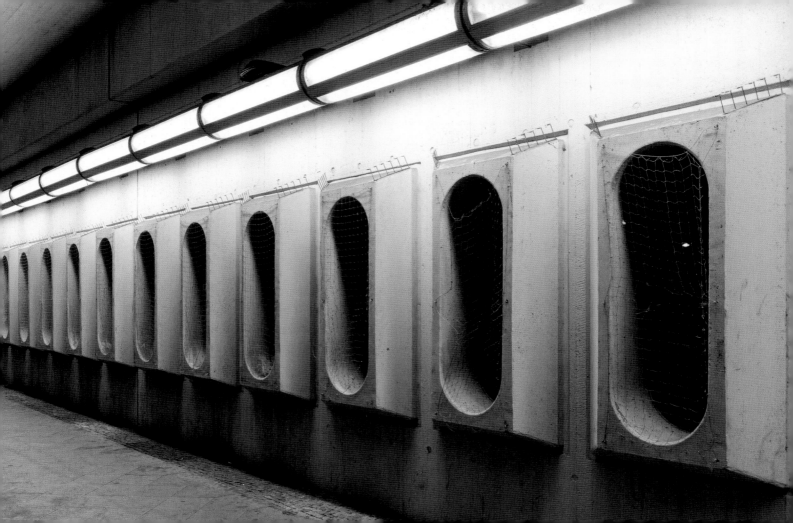

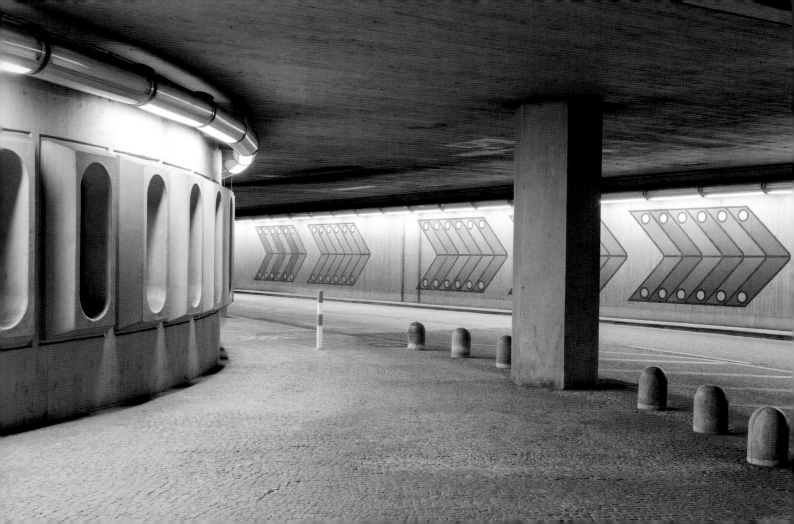

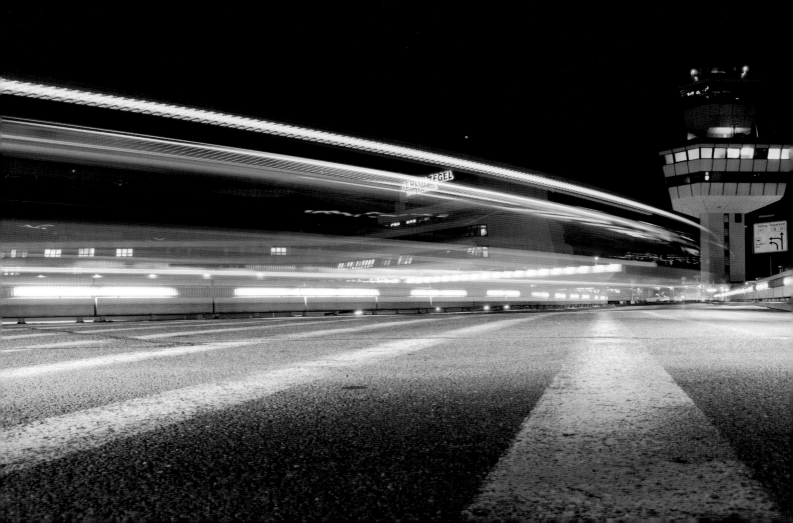

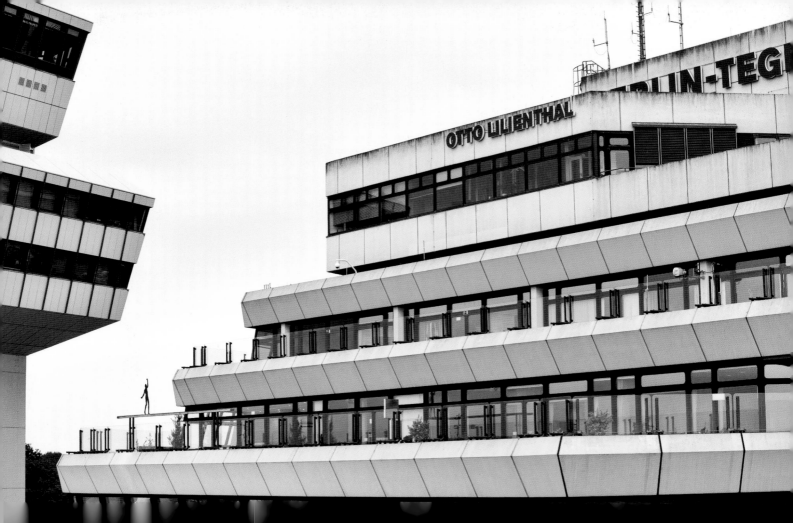

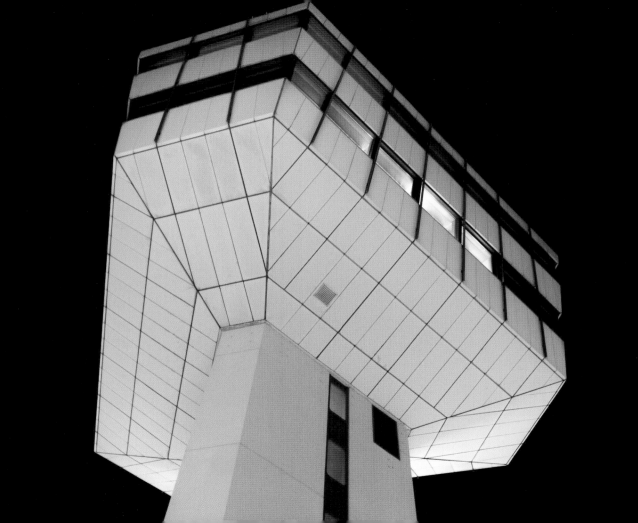

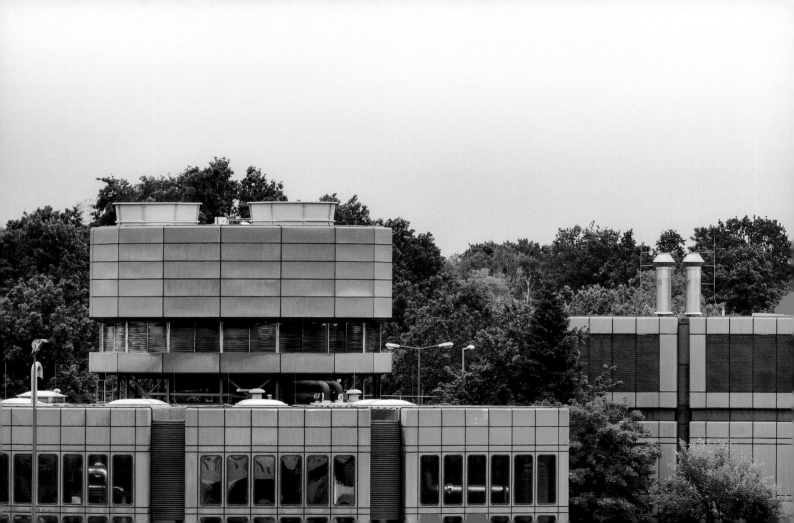

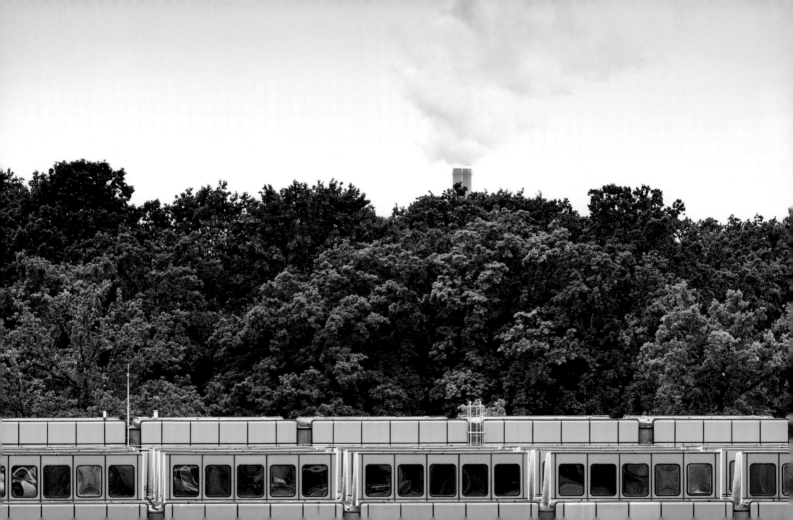

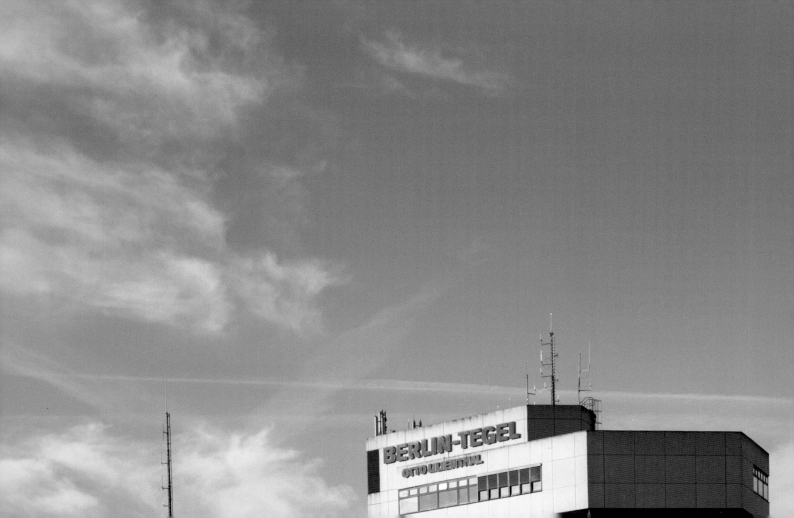

Peter Ortner (geboren 1967) studierte Philosophie, Literaturwissenschaft sowie Geschichte und ist seit 2007 freier Fotograf für Architektur, Dokumentation und Werbung. Wiederholt führte ihn sein fotografisches Arbeiten in den osteuropäischen und postsowjetischen Raum, insbesondere nach Zentralasien. Dabei entstanden unter anderem Aufnahmen von Bushaltestellen, die 2016 im jovis Verlag unter dem Titel „Back in the USSR. Soviet Roadside Architecture from Samarkand to Yerevan" veröffentlicht wurden.

Ausgangspunkt dieser Reisen war immer wieder der Flughafen Berlin-Tegel, dessen originale Einbauten und Strukturen Ortner von Mal zu Mal mehr zu schätzen lernte. Kurz vor der Schließung des TXL war es dem Fotografen ein großes Anliegen, den Wesenskern dieses Bauwerks mit den Augen eines Flaneurs zu durchdringen und festzuhalten. Ortner lebt und arbeitet in Nürnberg.

Peter Ortner (born 1967) studied philosophy, literature, and history and has been a freelance photographer in the fields of architecture, documentation, and advertising since 2007. His photographic work has repeatedly taken him to Eastern Europe and post-Soviet countries, especially to Central Asia. Among other things, this led to photographs of bus stops published by jovis Verlag in 2016 under the title "Back in the USSR: Soviet Roadside Architecture from Samarkand to Yerevan."

Ortner's journeys often began at the Berlin-Tegel airport, where with each trip he came to increasingly appreciate the building's original installations and structures. As the closure of TXL drew closer, he took a deep personal interest in penetrating and capturing the essence of the building with the eyes of a flâneur. Ortner lives and works in Nuremberg.

Lektorat (Deutsch): Theresa Hartherz, jovis, Berlin
Gestaltung und Satz: Susanne Rösler, jovis, Berlin
Lithografie: Bild1Druck, Berlin
Gedruckt in der Europäischen Union

Bibliografische Information der Deutschen Nationalbibliothek
Die Deutsche Nationalbibliothek verzeichnet diese Publikation
in der Deutschen Nationalbibliografie; detaillierte bibliografische
Daten sind im Internet über http://dnb.d-nb.de abrufbar.

jovis Verlag GmbH
Kurfürstenstraße 15/16
10785 Berlin

www.jovis.de

jovis-Bücher sind weltweit im ausgewählten Buchhandel erhält-
lich. Informationen zu unserem internationalen Vertrieb erhalten
Sie von Ihrem Buchhändler oder unter www.jovis.de.

ISBN 978-3-86859-631-1

Translation: Michael Thomas Taylor, Berlin
Design and setting: Susanne Rösler, jovis, Berlin
Lithography: Bild1Druck, Berlin
Printed in the European Union

Bibliographic information published by the Deutsche National-
bibliothek: The Deutsche Nationalbibliothek lists this publication
in the Deutsche Nationalbibliografie; detailed bibliographic data
are available on the Internet at http://dnb.d-nb.de.

jovis Verlag GmbH
Kurfürstenstraße 15/16
10785 Berlin

www.jovis.de

jovis books are available worldwide in select bookstores. Please
contact your nearest bookseller or visit www.jovis.de for
information concerning your local distribution.

ISBN 978-3-86859-631-1

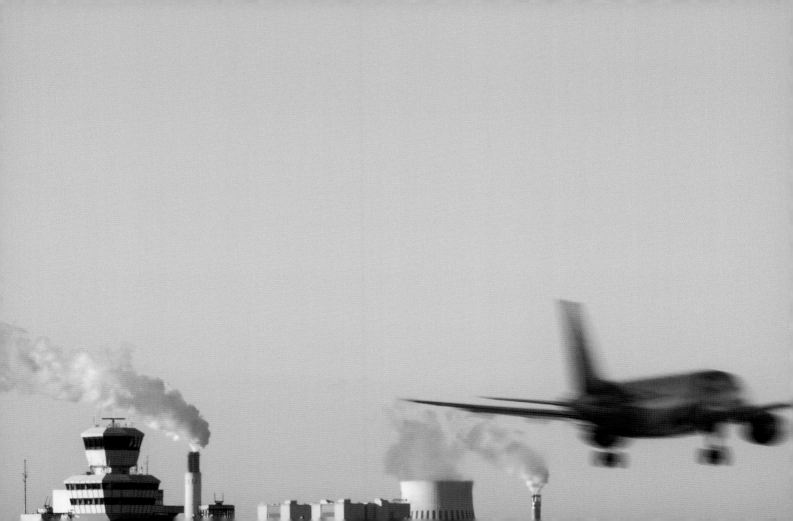

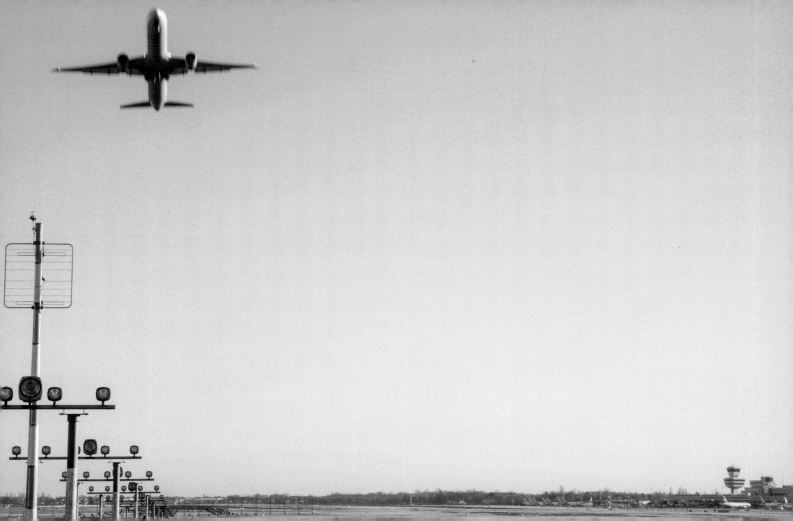